Hillsmere Elementary,

It is with great pleasure to provide you
with the life history of the bald eagle
in the Chesapeake Bay, captured through
photography.

I hope that all of you find your passion
and can lead a path to a job just like
I did! Look to the sky — the
eagles are back.

Craig A. Koppie
Dec. 2013

Inside A Bald Eagle's Nest

Inside A Bald Eagle's Nest

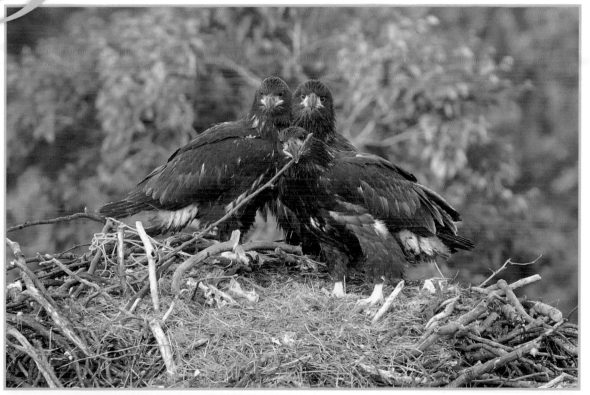

A Photographic Journey

through the American
Bald Eagle Nesting Season

Teena Ruark Gorrow
& Craig A. Koppie

Schiffer Publishing Ltd

4880 Lower Valley Road • Atglen, PA 19310

Published by Schiffer Publishing, Ltd.
4880 Lower Valley Road
Atglen, PA 19310
Phone: (610) 593-1777; Fax: (610) 593-2002
E-mail: Info@schifferbooks.com

For our complete selection of fine books on this and related subjects, please visit our website at **www.schifferbooks.com.** You may also write for a free catalog.

This book may be purchased from the publisher. Please try your bookstore first.

We are always looking for people to write books on new and related subjects. If you have an idea for a book, please contact us at proposals@schifferbooks.com

Schiffer Publishing's titles are available at special discounts for bulk purchases for sales promotions or premiums. Special editions, including personalized covers, corporate imprints, and excerpts can be created in large quantities for special needs. For more information, contact the publisher.

Photographs © 2013 by Craig A. Koppie unless otherwise noted. Other photographs included are provided courtesy of Teena Ruark Gorrow; the Virginia Department of Game and Inland Fisheries; Sutton Avian Research Center and Stephen Fettig; and Dr. James W. Carpenter, David H. Ellis, and U.S. Fish & Wildlife Service.

Type set in Trajan Pro/Korinna BT

ISBN: 978-0-7643-4464-0
Printed in China

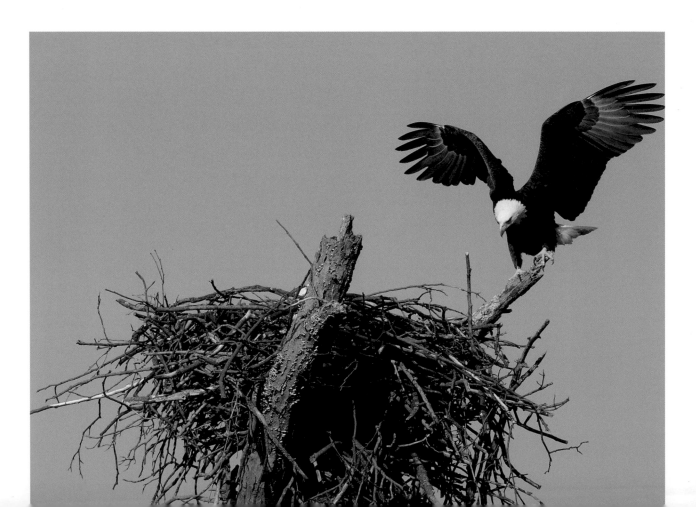

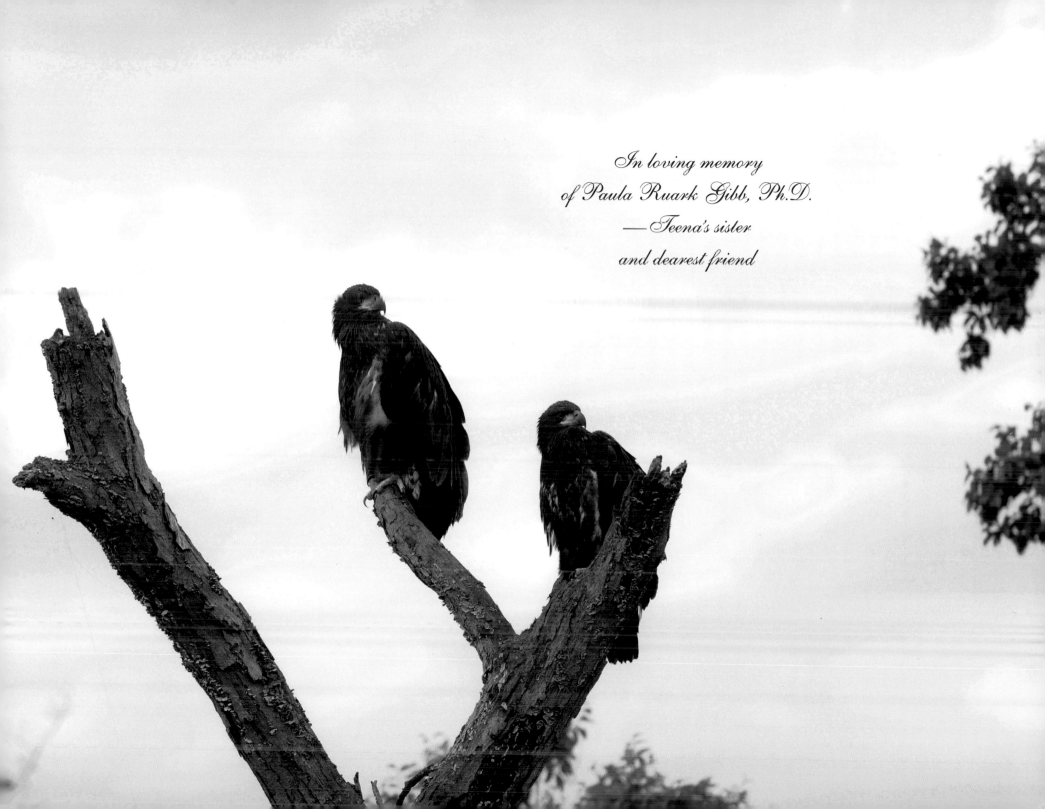

In loving memory
of Paula Ruark Gibb, Ph.D.
— Teena's sister
and dearest friend

WE REVERENTLY DEDICATE THIS BOOK TO GOD
AND FAMILY MEMBERS, AS FOLLOWS:

To my precious parents, Paul and Ellen Ruark,
whom I honor, cherish, and adore.

To Wayne Gorrow, my husband
and the love of my life.

To Ernest Beath III, the apple of my eye.

—Teena

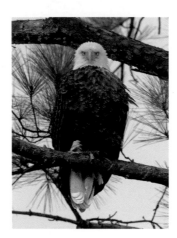

To my loving parents, Tony and Nancy Koppie, who
inspired me to follow my dreams.

To my wonderful wife, Pamela Koppie, and our
children, Lindsey and David, for their sacrifice
and understanding.

To my brothers, Cary and Jeff, and sister,
Pamela Jean, and their families who helped me
in my life's pursuits.

—Craig

EPIGRAPH

"The founding fathers made an appropriate choice when they selected the Bald Eagle as the Emblem of our nation. The fierce beauty and proud independence of this great bird aptly symbolizes the strength and freedom of America. But as latter day citizens we shall have failed a trust if we permit the Eagle to disappear..."

—*John F. Kennedy,* Excerpt taken from a letter dated July 18, 1961, written by President Kennedy to Mr. Charles H. Callison, Special Assistant to the President, National Audubon Society.*

*http://www.jfklibrary.org/
Research/Ready-reference/
jfk-Miscellaneous-Information/
Appeal-Bald-eagle.aspx

CONTENTS

FOREWORD

The bald eagle is a remarkable success story in wildlife conservation. From just a few hundred known pairs in the early 1970s, bald eagles have rebounded to well over 70,000 individuals in the lower 48 states today. This recovery resulted from a ban on the use of the pesticide DDT in the United States in 1972.

The rapid growth in bald eagle numbers brings with it some interesting tales, not the least of which is the expansion of nesting bald eagles into urban and suburban areas. Urban-nesting bald eagles provide an incredible opportunity for people to get a first-hand look at the life of an eagle pair. Studies in Florida also show that these urban nests contribute greatly to the growth of bald eagle populations.

This book presents a timely, eagle-eye view of this phenomenon. As a raptor biologist who has worked with bald eagles since the 1970s, I'm extremely pleased to see this book, not just because it's a well-written and engaging story, but because it describes something no one would have imagined 40 years ago. So sit back, relax, and enjoy a true-life good-news story!

—*Mr. Brian Millsap*, National Raptor Coordinator, U.S. Fish and Wildlife Service
Albuquerque, New Mexico
October 22, 2012

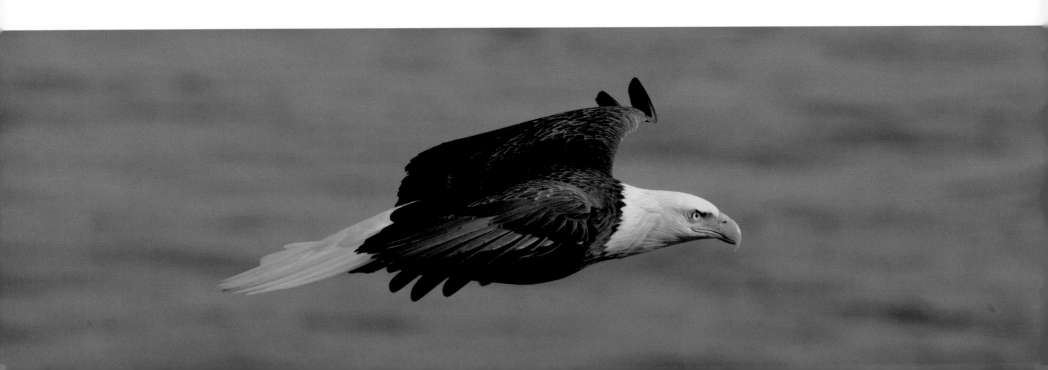

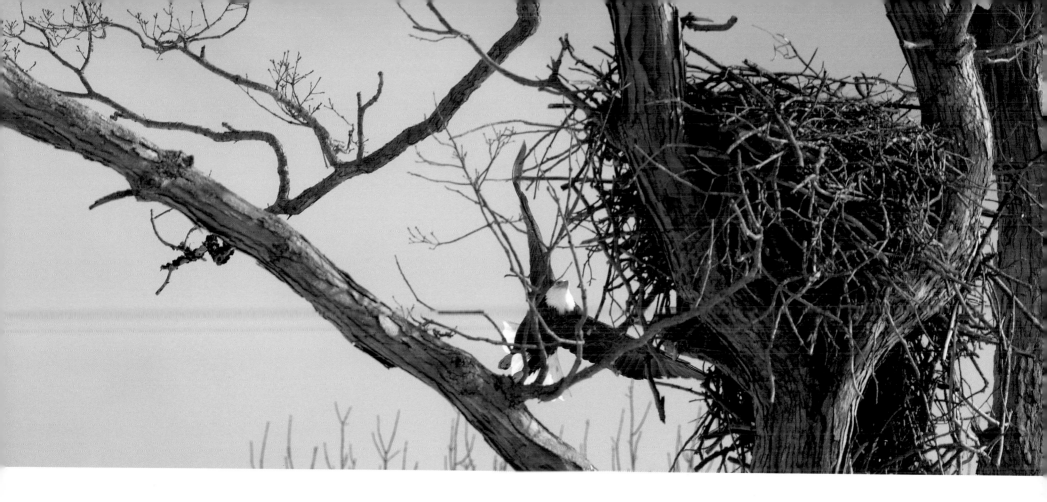

Acknowledgments

We gratefully acknowledge our family members, friends, and colleagues for their support as we pursued our passion for eagles. We extend our sincere appreciation to Mr. and Mrs. William Dalton and Mr. and Mrs. Donald Bates; Jeffrey B. Trollinger, Stephen Living, and the Virginia Department of Game and Inland Fisheries; Steve K. Sherrod, Stephen Fettig, and Sutton Avian Research Center; and Nell Baldacchino, James W. Carpenter, David H. Ellis, Randy Loftus, and the U.S. Fish & Wildlife Service. We recognize the years of effort invested in eagle recovery by U.S. Fish & Wildlife Service personnel and offer our gratitude to Brian Millsap. We also thank Schiffer Publishing for making our dream of sharing eagle stories a reality.

INTRODUCTION

The bald eagle, *Haliaeetus leucocephalus*, is America's national bird and symbol. It is a large raptor, or bird of prey, found only in North America. This American icon symbolizes freedom, power, grace, and resilience.

These majestic birds soared the skies in abundance when named the United States emblem in 1782. However, by the mid-1900s, they had almost vanished and were at risk of becoming extinct. Changing landscapes and urban sprawl claimed natural habitat, leaving fewer places in the wild for eagles to nest and forage. They were also being illegally hunted and killed. The use of dangerous pesticides, like DDT, harmed eagles and their eggs.

With only a small population of bald eagles still alive, many people were concerned that these magnificent creatures would soon be gone forever. Scientists, lawmakers, government agencies, and citizens worked together to save them. DDT was banned from use and the bald eagle was officially listed as an endangered species, protected under the Endangered Species Act.

Today, bald eagles have made a comeback and their numbers continue to rise. While they are no longer endangered, they are still safeguarded by the Bald and Golden Eagle Protection Act and the Migratory Bird Treaty Act. Indeed, eagles still face very real threats to long-term survival and their resilience is being tested in ways unforeseen just years ago.

Through this book, we hope to facilitate an understanding of the bald eagle's way of life, illustrate its behaviors during nesting season, and foster its protection. *Inside a Bald Eagle's Nest* presents a photographic journey into the nesting season of American bald eagles living in a suburban neighborhood outside of Washington, D.C. This factual account offers a rare glimpse into the behaviors and ecology of America's symbol as it prepares a nest, mates, lays eggs, and rears offspring.

While we focused on one mated nesting pair, other eagles were included in our observations and this book. We usually watched from a blind or other natural cover, and most photographs were captured in the eagles' natural environment using a telephoto lens. Some photographs were obtained through a nest cam or from an avian research center.

The bald eagle has captivated our imaginations for years. It is an honor to present our story about America's bird and the way it raises and cares for its young.

Sincerely,

Teena Ruark Gorrow

Teena Ruark Gorrow

Craig A. Koppie

Craig A. Koppie

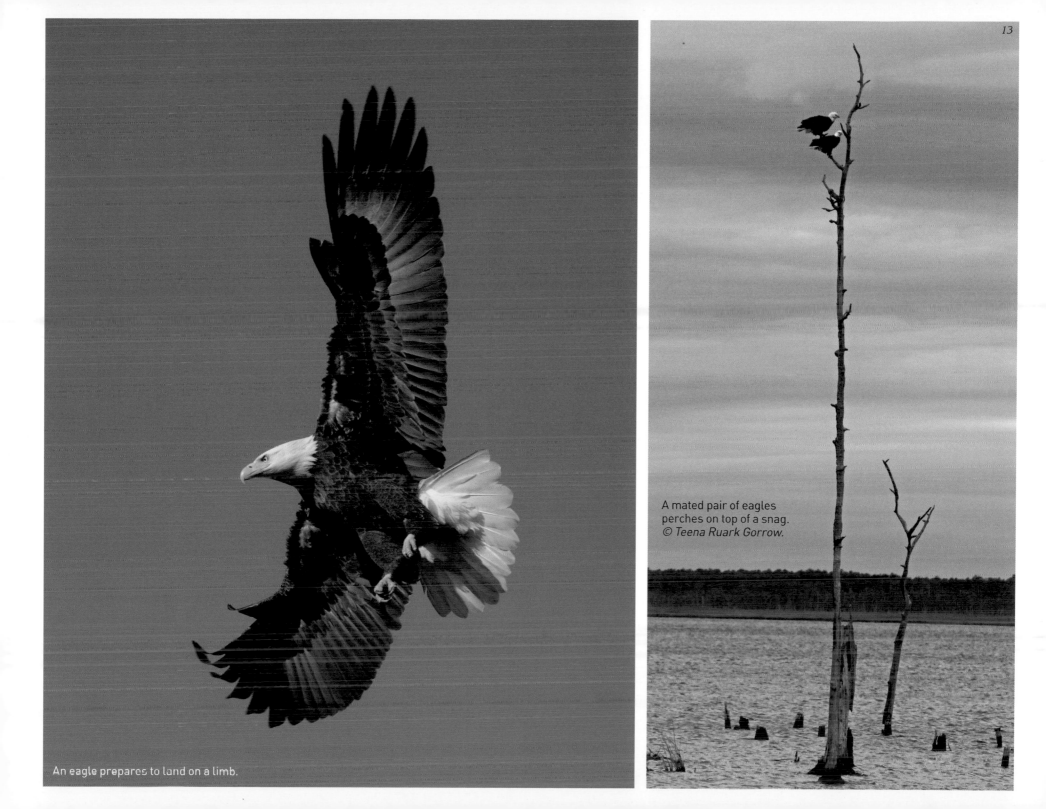

An eagle prepares to land on a limb.

A mated pair of eagles perches on top of a snag. © *Teena Ruark Gorrow*.

INSIDE A BALD EAGLE'S NEST

About 80 feet above the ground, in the top limbs of an old white oak tree, a pair of American bald eagles built their nest. Year after year, the eagle couple returns to this tree during autumn. They prepare the nest for egg-laying and live here until their offspring fledge in early summer.

For now, it is quiet inside this bald eagle nest. But, that will soon change. Fall has arrived. Cooler temperatures and shorter days signal the eagles back to their territory. It will soon be time for nesting season to begin once again.

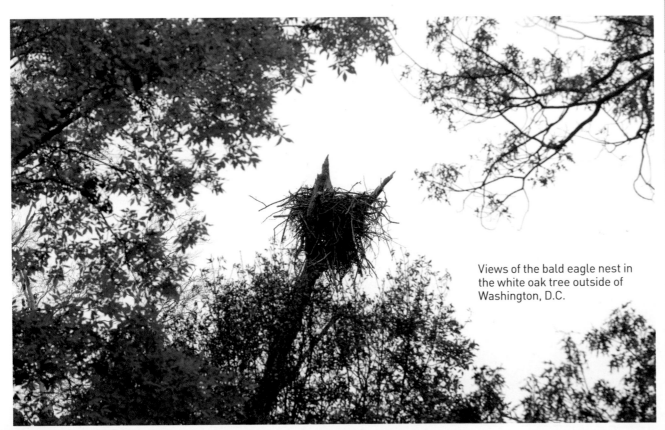

Views of the bald eagle nest in the white oak tree outside of Washington, D.C.

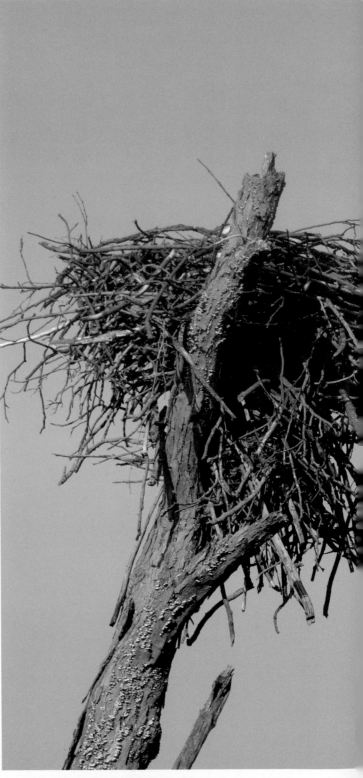

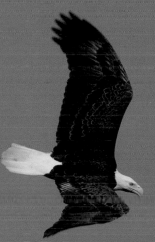

With wings outstretched, two adult bald eagles soar high in the sky above the old white oak tree. Sunlight gleams across white head and tail feathers as these magnificent raptors glide through the air. One flies in front, then they briefly separate before circling back together. They seem to be enjoying this beautiful October day catching wind currents above the Potomac River.

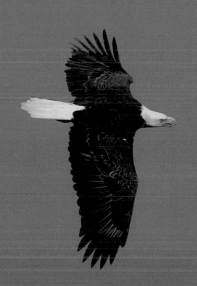

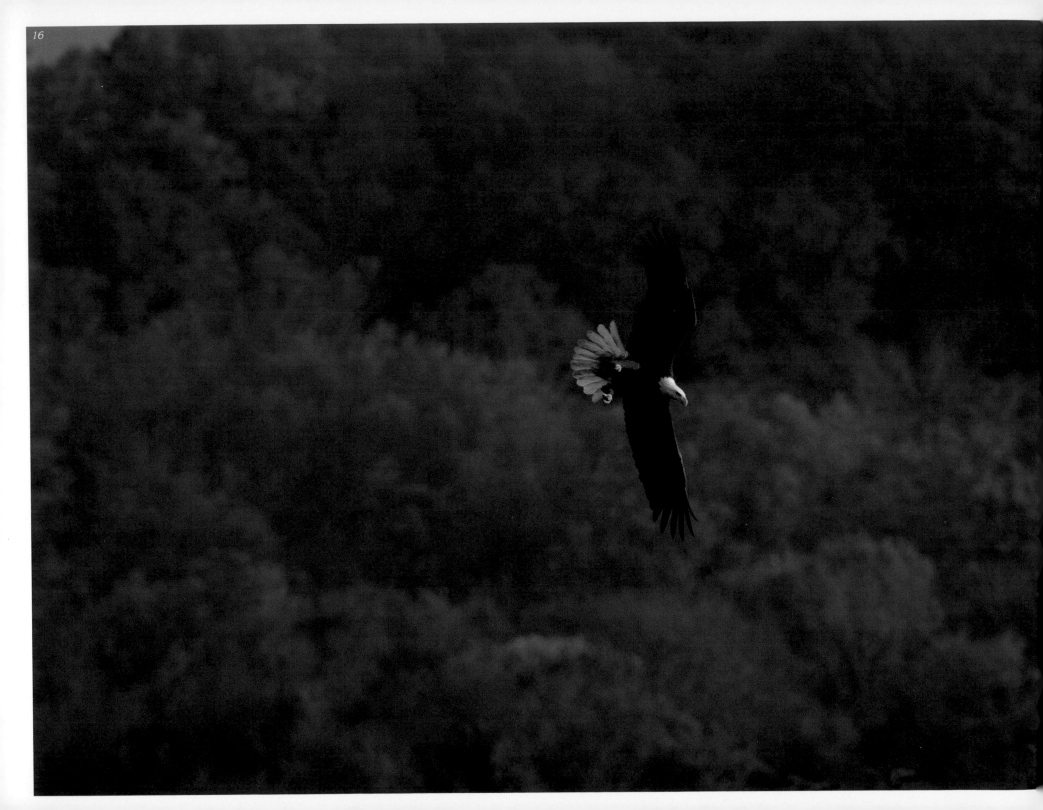

The mated eagle pair has returned to their territory for nesting season. Although they will not focus on nest preparation or lay eggs for a few months, they announce their presence to other eagles and secure their breeding area. They spend autumn days mounting the skies, foraging for prey, and perching side-by-side. One eagle occasionally perches on the nest in the white oak while the other is perched on a nearby snag. They also perch together for brief periods of time inside the nest. At night, they roost high up in the canopy of tall, mature trees near their nest.

They are home.

The eagle pair gets reacquainted at their nest.

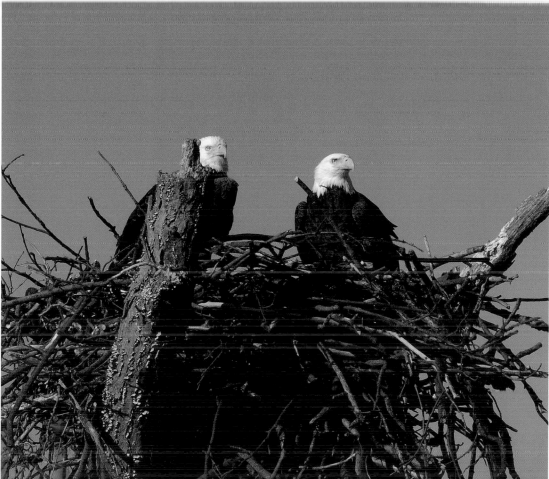

The eagle captures a fish and heads for the nest.

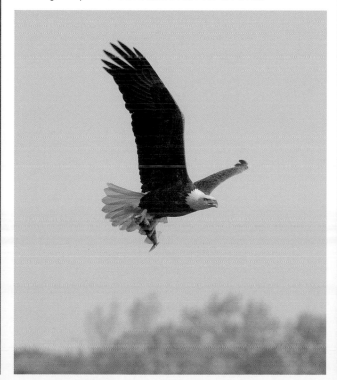

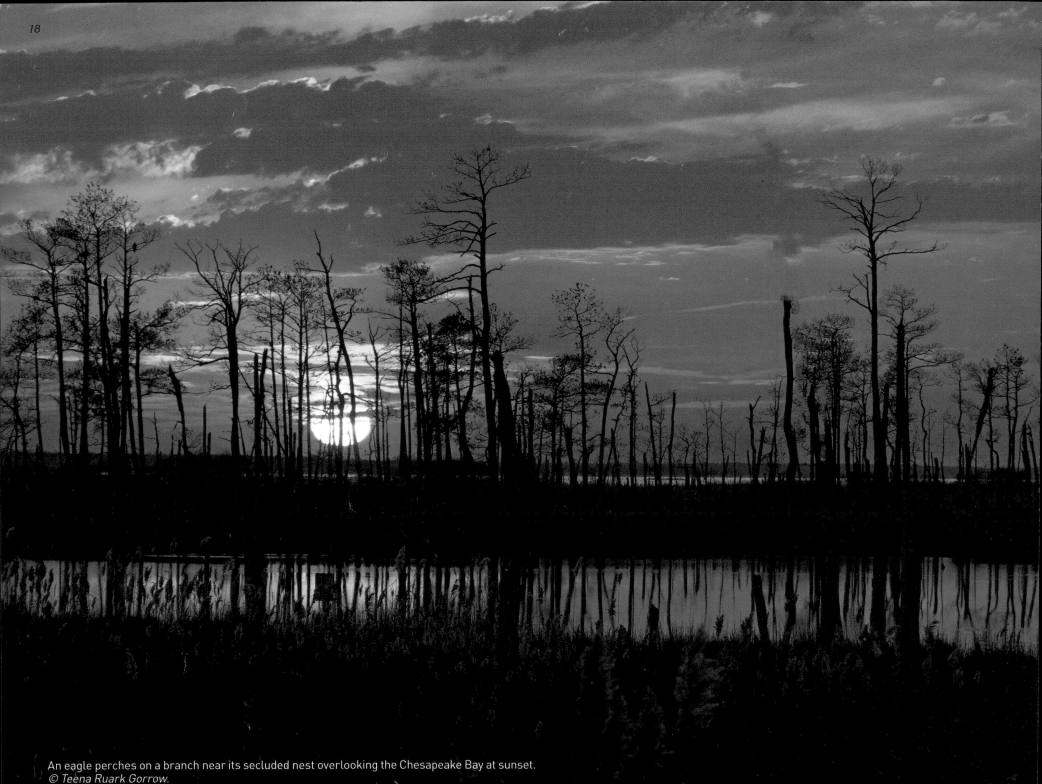

An eagle perches on a branch near its secluded nest overlooking the Chesapeake Bay at sunset.
© Teena Ruark Gorrow.

Eagles usually claim nesting territory in natural habitat buffered from people. They seem to prefer undisturbed forests or shorelines with tall trees for safe perching and roosting.

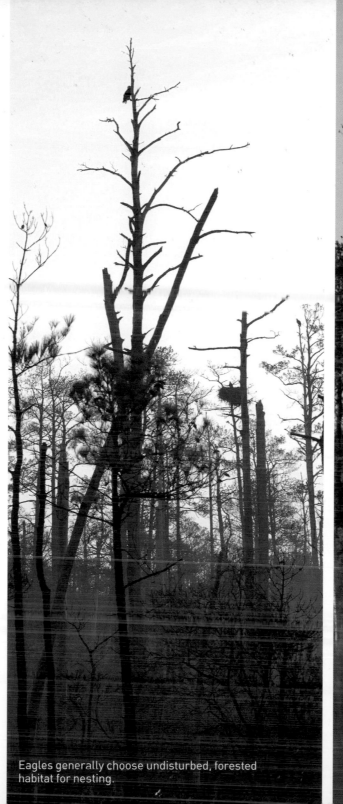

Eagles generally choose undisturbed, forested habitat for nesting.

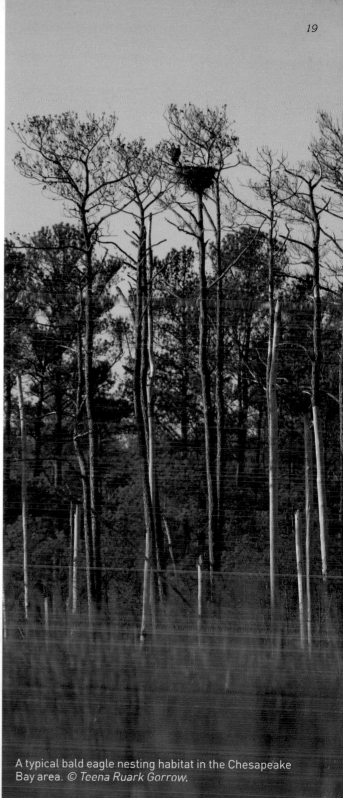

A typical bald eagle nesting habitat in the Chesapeake Bay area. © Teena Ruark Gorrow.

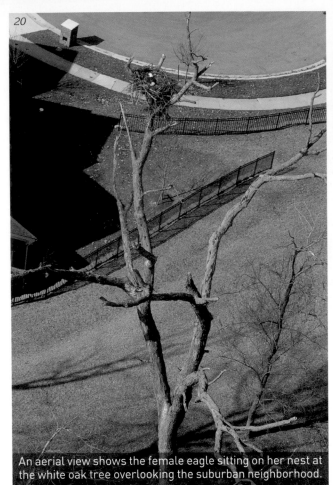

An aerial view shows the female eagle sitting on her nest at the white oak tree overlooking the suburban neighborhood.

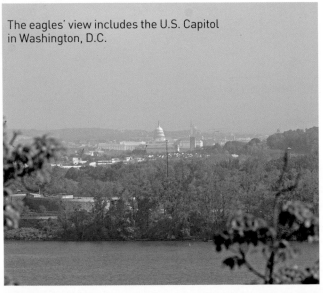

The eagles' view includes the U.S. Capitol in Washington, D.C.

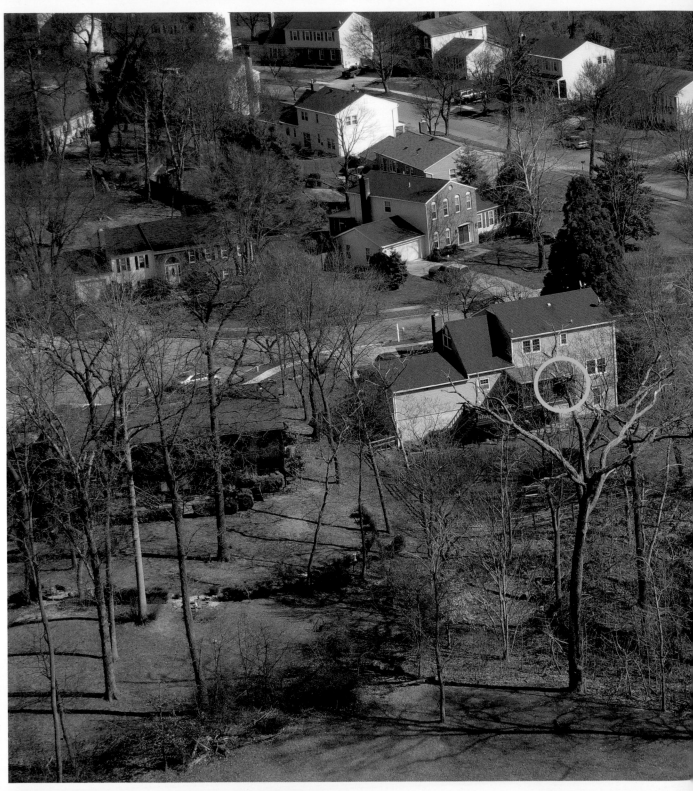

But, the eagle pair at the old white oak selected breeding territory in a busy neighborhood just outside of Washington, D.C. Their nest tree stands near homes where people are engaged in everyday life. Yards, driveways, sidewalks, and community roads reflect the buzz of suburbia.

The eagles' view-shed extends well beyond the suburb. While perched on the nest, these raptors can observe a myriad of events taking place for miles in all directions with just a turn of their heads. They witness the bustle near the U.S. Capitol, well-known monuments, and office buildings. Day after day, they see people commuting to and from work, watch traffic moving along congested highways around the D.C. area, and listen to the sounds of human activities. They are also acquainted with the sights and sounds of construction, and watch from a distance as cranes hoist materials to erect more buildings, roads, and parking garages. Smokestacks, light fixtures, power lines, and tall buildings adorn their skyline.

The female eagle forages for fish along the Potomac River about ¼ miles from the nest.

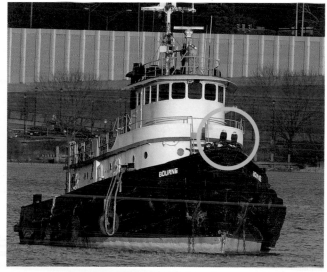

The mated eagle pair takes a break on the bow of a moored tugboat on the Potomac River.

An aerial view illustrates the nest in the white oak tree and the suburban neighborhood where the mated eagle pair lives.

Because the nest tree is adjacent to a flight path for a major airport, there is frequent aerial action for the eagle pair to observe. Large airplanes and helicopters, including those carrying the President of the United States and the U.S. Park Police, use the skies above the nest. The Discovery Space Shuttle has been flown overhead en route to the Smithsonian Institution's National Air and Space Museum.

The eagle couple has a clear view of the Potomac River from the nest, as well. Various boats, operated along this waterway on any given day, represent human interests beyond those that are work-related. Bass fishermen are drawn to this area because the Potomac hosts one of the East Coast's premiere bass fisheries. In fact, fishing tournaments, with impressive cash awards for the largest catch, are often held on these waters. In addition, recreational boats zoom by and scores of sailboats drift along the shoreline.

Without a doubt, the eagles at the white oak monitor countless goings-on within their immediate territory and well beyond their tree. American bald eagles now live in the suburbs.

The nest tree stands in the Capitol region safeguarded by the U.S. Park Police.

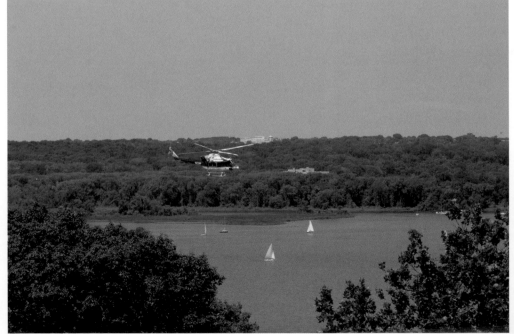

The Discovery Space Shuttle was flown near the nest en route to the Smithsonian Institution's National Air and Space Museum.

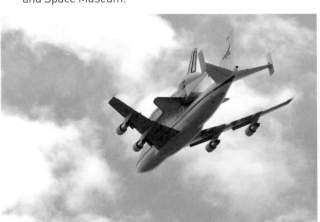

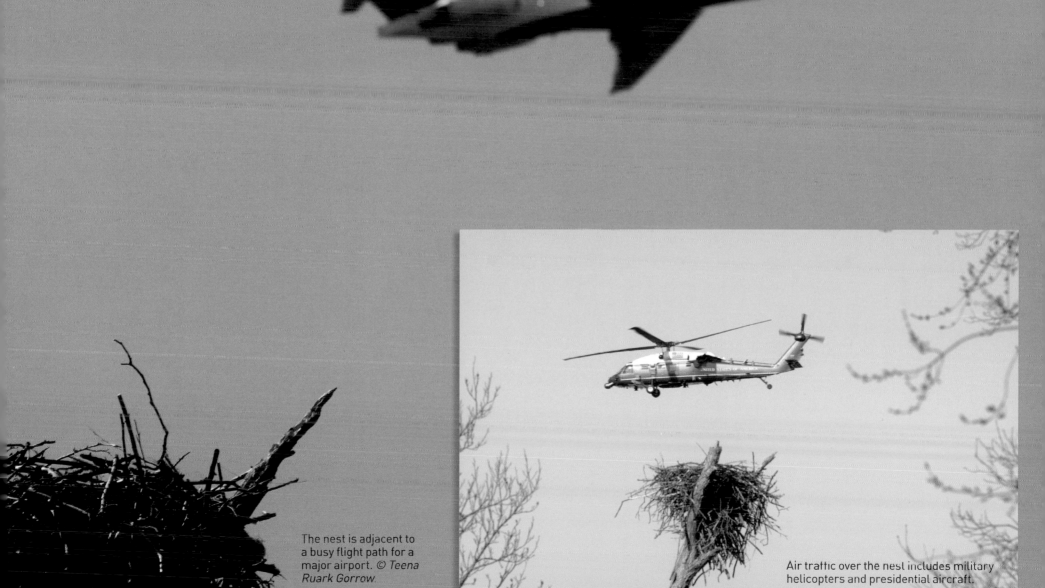

The nest is adjacent to a busy flight path for a major airport. © *Teena Ruark Gorrow.*

Air traffic over the nest includes military helicopters and presidential aircraft.

It might seem surprising that the mated pair would build a nest in such a busy location. Bald eagles are not naturally inclined to live near people and expanding into an urbanized area poses survival threats not experienced in remote habitat.

For example, it can be very dangerous for raptors with such large wings to live near manmade infrastructure often associated with heavily populated areas. Collisions with power lines, poles, and towers can result in electrocution or other serious injury.

Infrastructure linked to wind turbines also poses serious hazards to eagles. Now springing up as single units and in groups at wind farms, turbines have massive blades which spin at 200 miles per hour near their tips. Collisions with this equipment will most likely be fatal to eagles living near or migrating through areas where these units are positioned.

Other kinds of collisions pose risks to eagles, as well. Because they will eat carrion and scavenge carcasses, eagles risk collisions with trains and automobiles when feeding on deer that have been struck along highways and railroads. Similarly, eagle collisions with aircraft have been documented around airports near water. While this pair does not live on airport property, low-flying aircraft are operated in the vicinity of their nest.

Even so, as natural landscapes and shorelines become fragmented due to sea-level rise or property development, mature trees are lost. The resident nesting eagles in those areas must then search for other places to breed and raise their offspring. As more and more prime eagle real estate disappears or becomes inhabited by people, there is less and less undisturbed territory where eagles can nest. Consequently, mated pairs get compressed into smaller areas of optimal habitat. This generally results in a lack of living space or inadequate food supply to support the eagle populations trying to live there. Eagles are then forced to compete for territory or relocate to areas occupied by humans, thereby expanding into urban and suburban areas.

From top:
Wind turbines will potentially have long-term negative effects on bald eagles living near or migrating through energy-producing areas.

Sea-level rise is gradually claiming eagle habitat in some coastal areas. © *Teena Ruark Gorrow.*

There continues to be competition between people and eagles for the same land resources. Property development and new road construction are taking place around this nest tree.

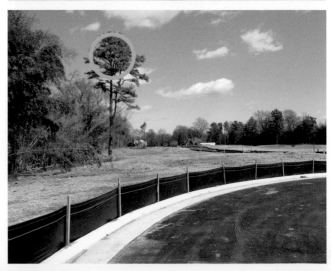

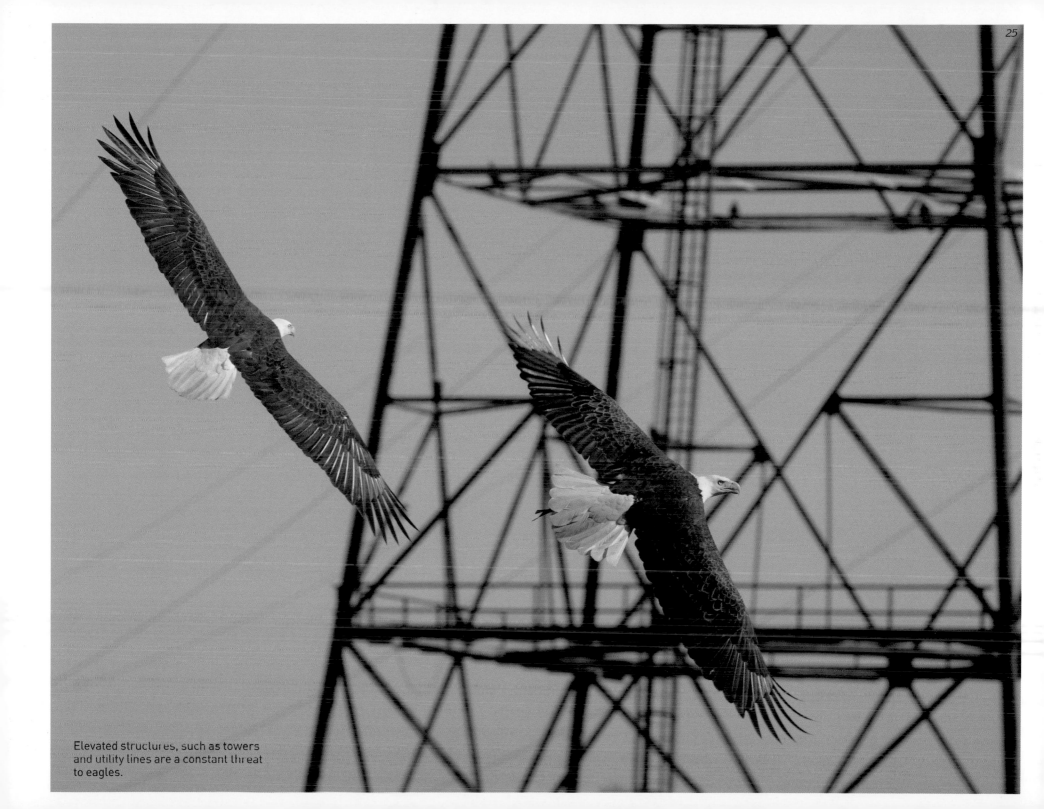

Elevated structures, such as towers
and utility lines are a constant threat
to eagles.

The exact reasons for territory and nest tree selection by this mated eagle pair will remain their secret. Perhaps they were forced into a suburban area because of land development in their former territory. Maybe they were unable to find natural habitat not already claimed by other eagles. Or, they might have hatched in the D.C. area, become acclimated to human activity, and returned when sexually mature to find a mate. Whatever their reasons, this eagle couple comes back to the white oak tree each year when it is time to breed. Inside this nest, the experienced pair has successfully raised more than a dozen eaglets.

Without a doubt, living in the suburbs presents a different lifestyle than that experienced on an undisturbed shoreline. Nonetheless, the eagles' basic survival needs, including food, water, space, and shelter, are being met in this habitat. The chosen tree overlooks the Potomac River which has an abundant array of fish to feed a growing family. If a different food source is desired, there are other areas for hunting prey including forests. The nest tree provides a clear view-shed so the pair can watch over the entire territory from the nest, as well as observe their home while perched in adjacent trees. Because the old oak stands apart from other trees in the area, the eagles have easy access to the nest with ample wing space to land and depart. There are also snags for perching and a nearby canopy of mature trees for roosting. Even with the commotion of human activity surrounding their nest, the eagles seem to have found a good place to call their home.

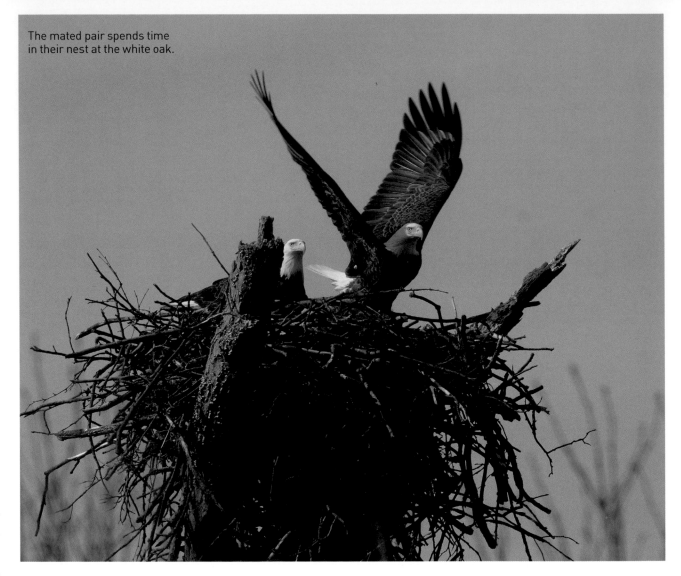

The mated pair spends time in their nest at the white oak.

But, the nest tree is decaying. Branches have rotted and fallen away from the trunk since the last breeding season. The limbs which support the nest structure are shorter, now reduced to just a few feet above the nest's rim. The weight of heavy nest materials, especially during inclement weather, could further damage the supporting limbs. The nest could also fall or become dislodged from the tree with use by the eagles' next brood.

Throughout the autumn months, as they spend time around the old tree, the eagle pair will decide if this is a secure place to raise offspring. Eagles often build several nests within their territory and the pair could select an alternative site when it is time to breed. By mid-November, it is clear that the couple intends to use the white oak for another season because they start nest preparation.

The male eagle departs the tree to search for nest material.

With their legs and strong talons, the eagles snap branches from nearby treetops and carry them one at a time to their nest. These usually range in size from two to three feet, with some as long as four feet. Thicker branches, between one half to one inch in diameter, are used to form the nest base, walls, and rim. Smaller branches are used inside and as filler around the nest walls.

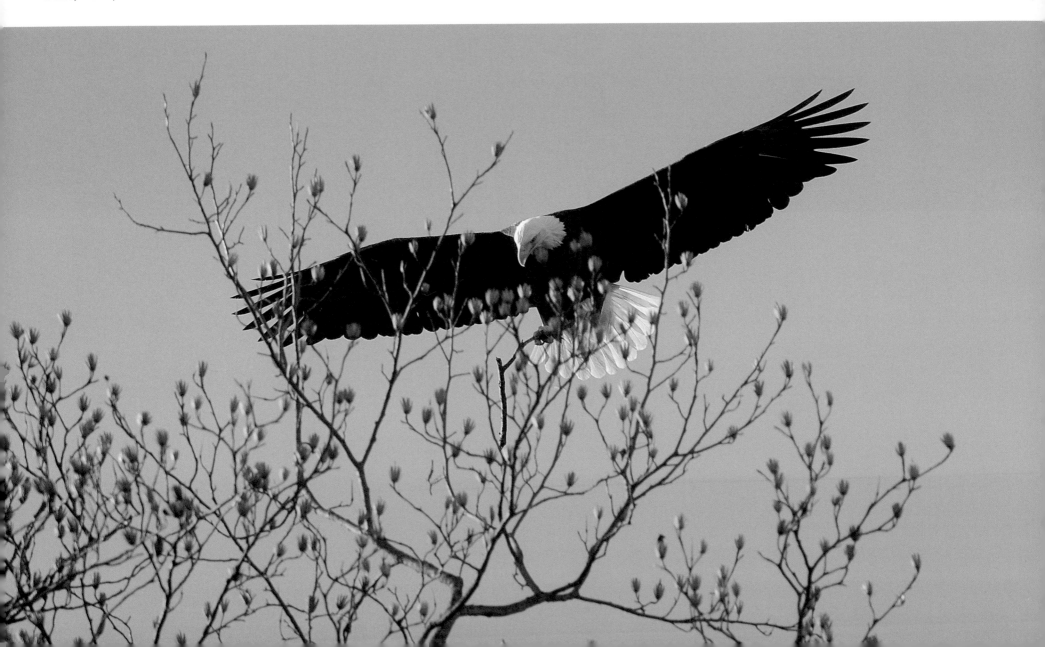

Both eagles fly back and forth, making countless trips between the nest and the surrounding trees for branches. It takes a lot of work, time, and energy to prepare a nest, even when it has been used for successive breeding seasons like the one constructed in the white oak. Many branches are needed to reinforce the outer nest walls, repair weather damage, and replace fallen sticks. In fact, since the last brood of eaglets grew and fledged from this nest, an earthquake shook the D.C. area and a hurricane traveled up the East Coast. Some shifting of nest materials also took place as a family of squirrels was raised inside the lower portion of the nest.

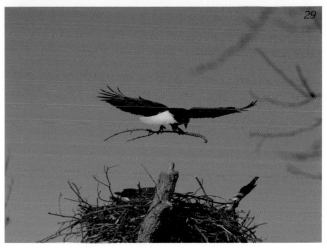

While the female weaves a branch in place on the nest rim, the male returns carrying the branch he collected.

The eagle's nest is home to small reptiles, birds, and mammals including gray and flying squirrels. A gray squirrel exits its nest within the nest at the oak tree.

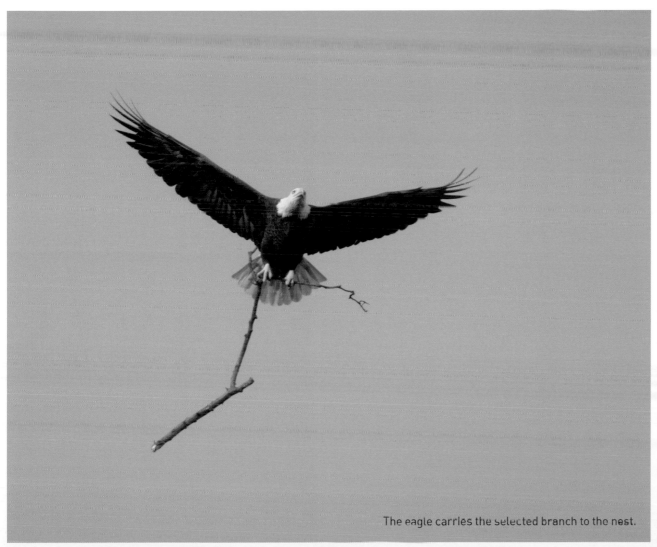

The eagle carries the selected branch to the nest.

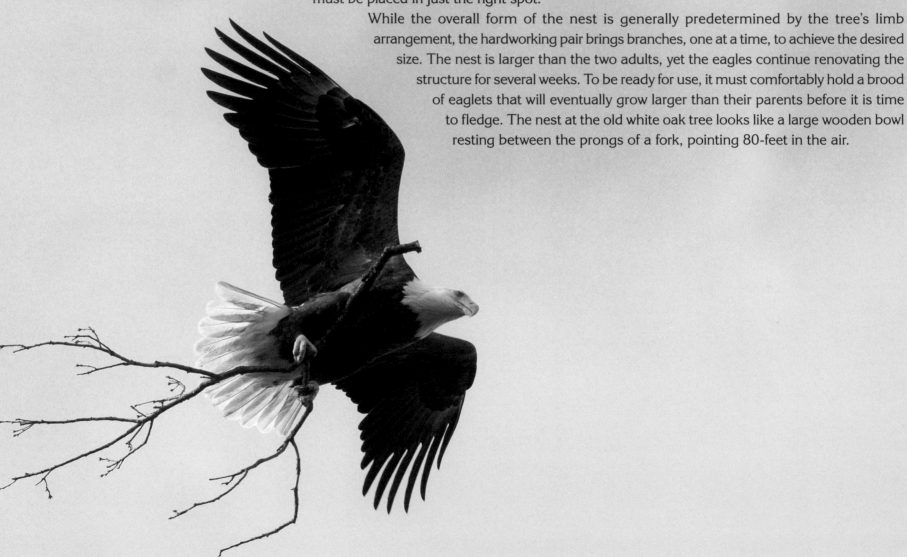

Skilled with nest construction, the male and female eagles weave each branch in place with their beaks and feet. They work well together and seem to have a common vision for the nest's final appearance. At times, when one leaves the nest to find building materials, the mate slightly adjusts the other's work. They have high standards of craftsmanship for their living quarters and each branch must be placed in just the right spot.

While the overall form of the nest is generally predetermined by the tree's limb arrangement, the hardworking pair brings branches, one at a time, to achieve the desired size. The nest is larger than the two adults, yet the eagles continue renovating the structure for several weeks. To be ready for use, it must comfortably hold a brood of eaglets that will eventually grow larger than their parents before it is time to fledge. The nest at the old white oak tree looks like a large wooden bowl resting between the prongs of a fork, pointing 80-feet in the air.

An eagle must be coordinated to hold and transport sticks to the nest.

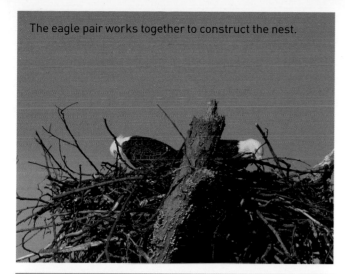
The eagle pair works together to construct the nest.

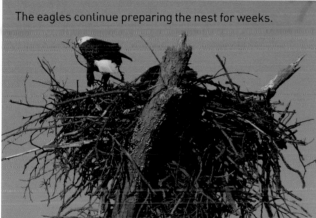
The eagles continue preparing the nest for weeks.

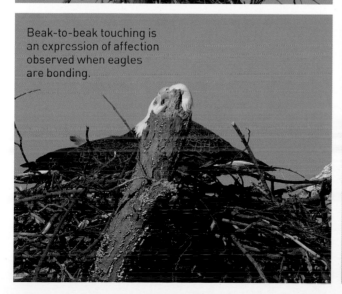
Beak-to-beak touching is an expression of affection observed when eagles are bonding.

Every now and then, the eagle couple takes a break from their work to bond. They perch side-by-side looking out over their territory. They often turn to face each other, or lean their heads toward each other and touch beaks. At times, their beaks open and close as if engaged in conversation. The female attentively listens as the male vocalizes, and occasionally pecks the male's beak. Their affection for and commitment to each other are unmistakable.

Eagles usually pair for life, taking a different mate only if the other dies or goes missing. Because eagles in the wild roam free and may live as long as 30 years, it is hard to know the exact ages of this pair or how long they have been a couple. But, they have returned to this territory for several breeding seasons and have been a twosome for some time now.

The female attentively listens as the male vocalizes.

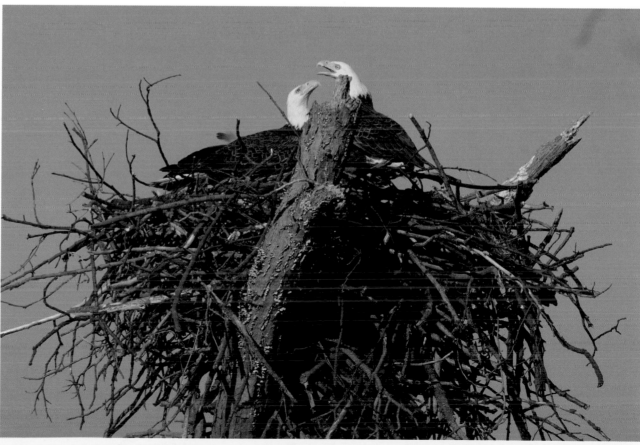

Their markings are characteristic of adult bald eagles. The plumage patterns on their wings and bodies are mostly brown with all white head and tail feathers. Powerful, yellow feet are outfitted with sharp, black talons. Piercing yellow eyes provide excellent vision which is significantly greater than that of a human being. Each eye is framed with a yellow brow, which can create distinct facial expressions to look quite fierce. The big, downward-curved beak is yellow and pointed. The larger of the two birds is likely the female because female raptors are known to be larger in size and weigh more than males. Eagles generally weigh between ten and fourteen pounds, measure about three feet long, and have a wingspan over six feet.

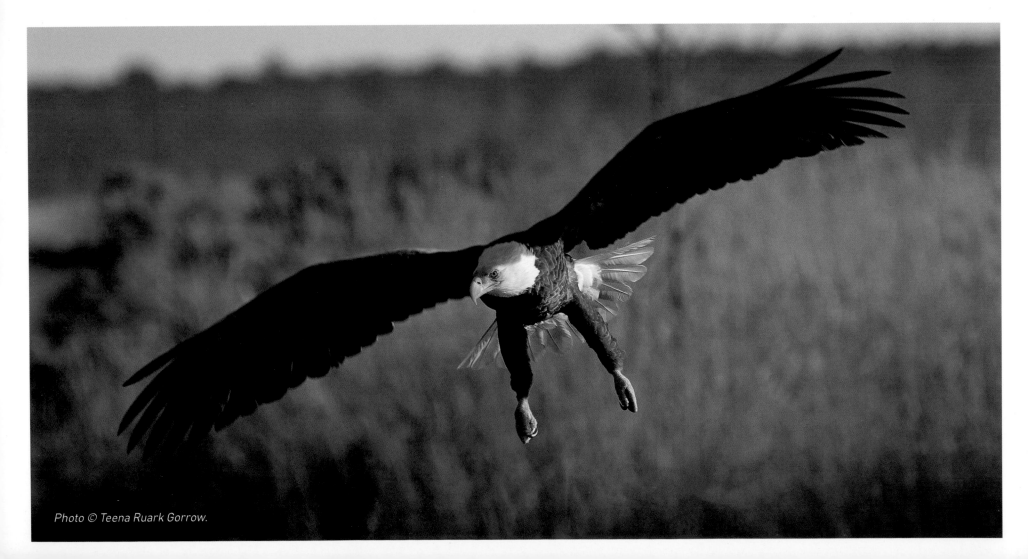

Photo © Teena Ruark Gorrow.

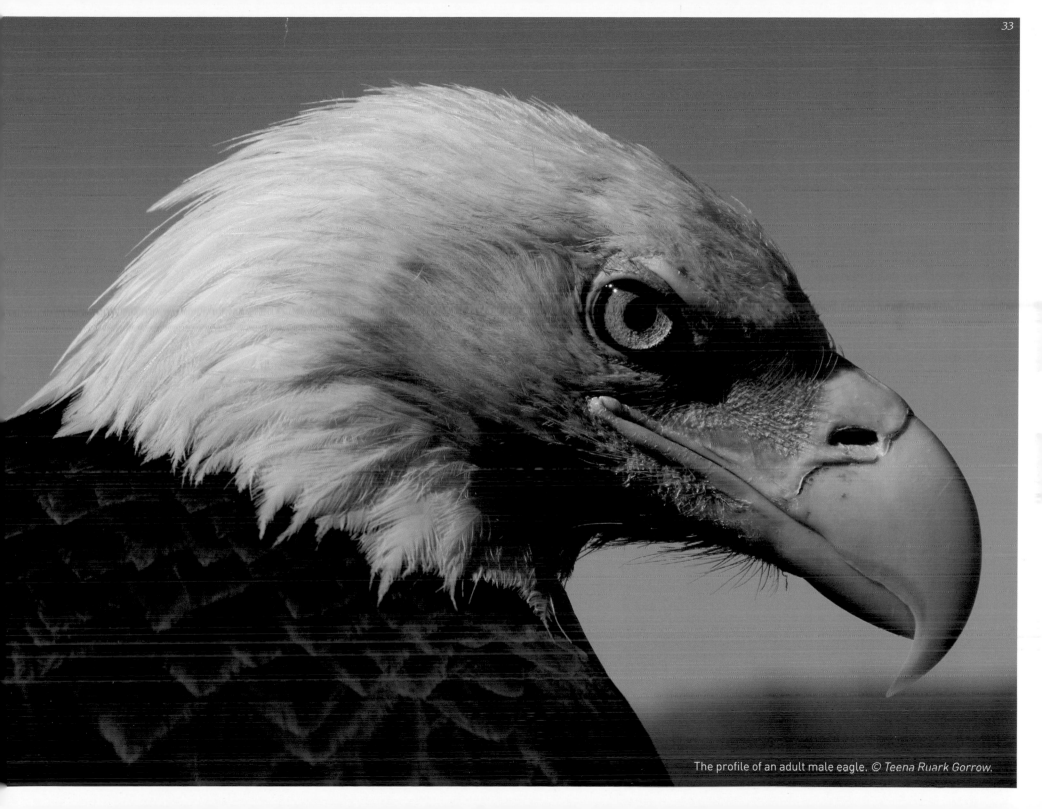

The profile of an adult male eagle. © *Teena Ruark Gorrow*.

Besides sticks, the eagles search for dried grasses, straw, and moss in the nearby fields. Using their beaks, they scatter these items in layers on the inside of the nest to cover the open spaces of crisscrossed sticks. Near the center of the nest, but slightly off to one side, they form a soft cup down under the grasses where the eggs will be laid. Additional dried grasses are piled in mounds like pillows around the lip of the egg cup for added protection and warmth.

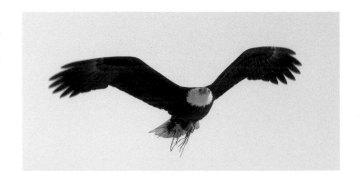

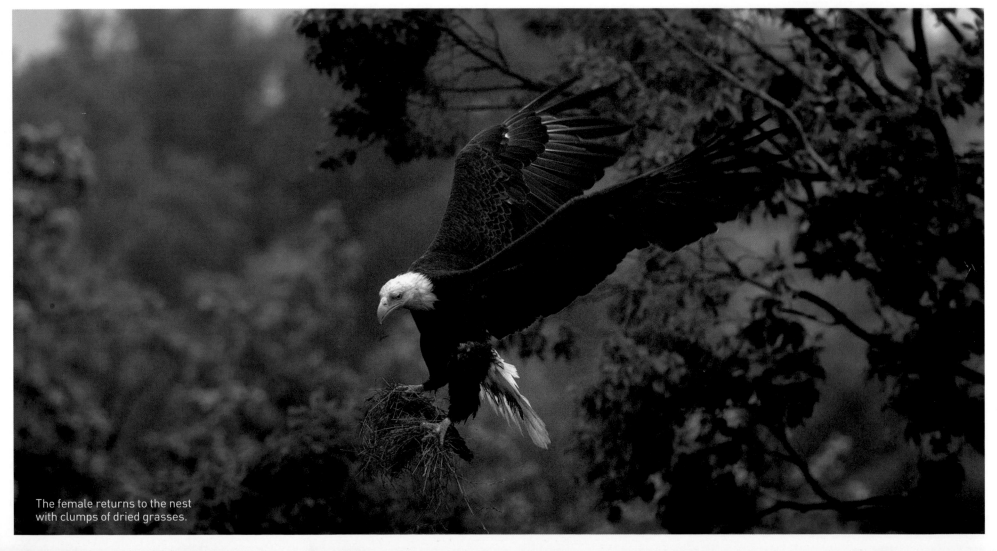

The female returns to the nest with clumps of dried grasses.

The eagles occasionally bring other items to their nest including sprigs of pine, pinecones, shells, and corncobs. These objects are intentionally placed in the nest by the pair, but the reasons behind these particular deliveries are not known for certain. Perhaps the sprigs of pine make the nest smell fresh and ward off insects. The pinecones might offer a pleasant fragrance, be decorative, or be used for play. While it is possible that the occasional oyster and clam shells are brought to the nest as prey, the shells could also be presented as gifts. The eagles possibly peck at the corncobs and use them as nesting material near the cup.

The eagles have prepared the nest for their next brood which features a distinct egg cup, fresh grasses, sprigs of pine, and a corncob.

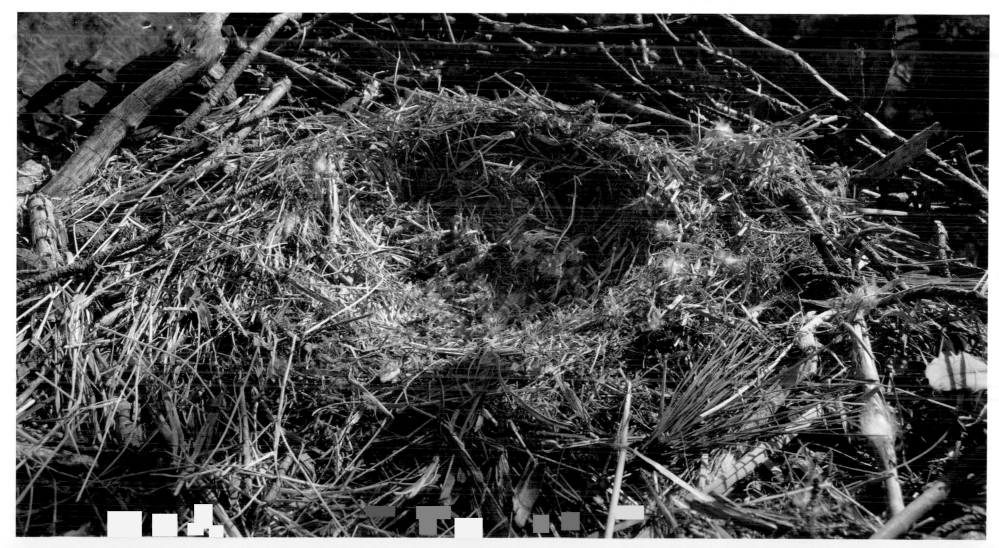

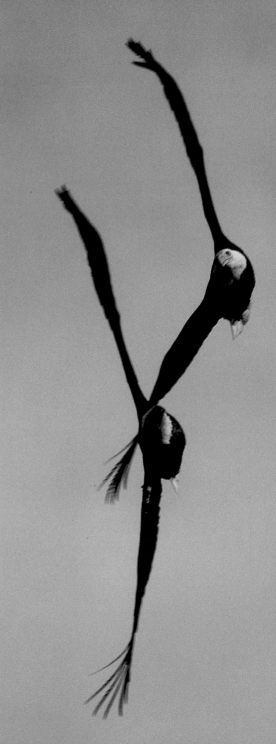

While the industrious eagles persist in preparing their nest, they also know when it is time to mate. The male and female meet high in the sky to start their courtship flight. Wing-to-wing, they glide. They fly in circles while he chases her. Like mirror images, their wings are equally spaced apart as they perform aerial maneuvers in perfect harmony. Fearlessly and with precision, they lock their feet together and cartwheel through the air in a free fall. Just before reaching the ground, the united couple unlocks their feet to soar skyward for another sky-dancing flight.

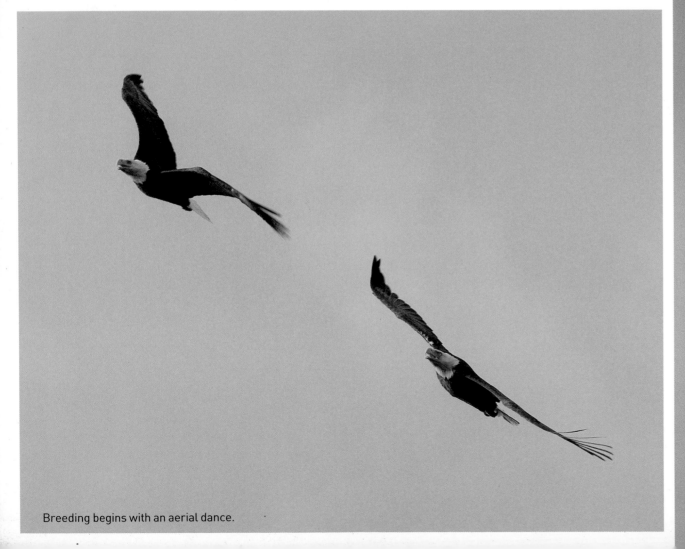

Breeding begins with an aerial dance.

After their courtship flight, the eagles fly to an open limb of a snag near the white oak. The male carefully lands on the female's back and they mate.

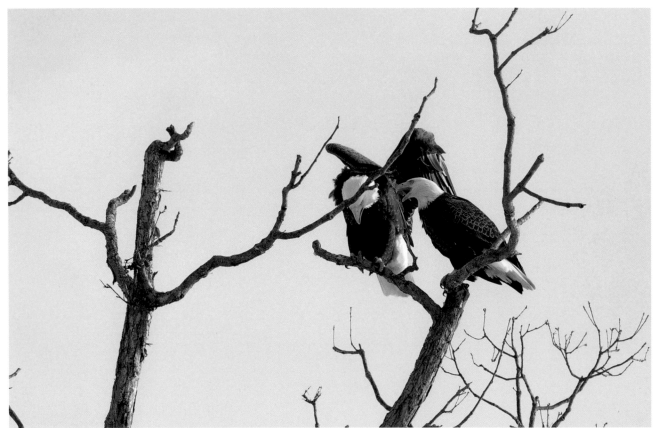

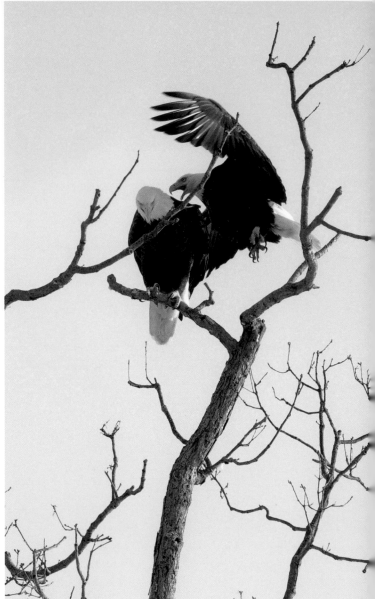

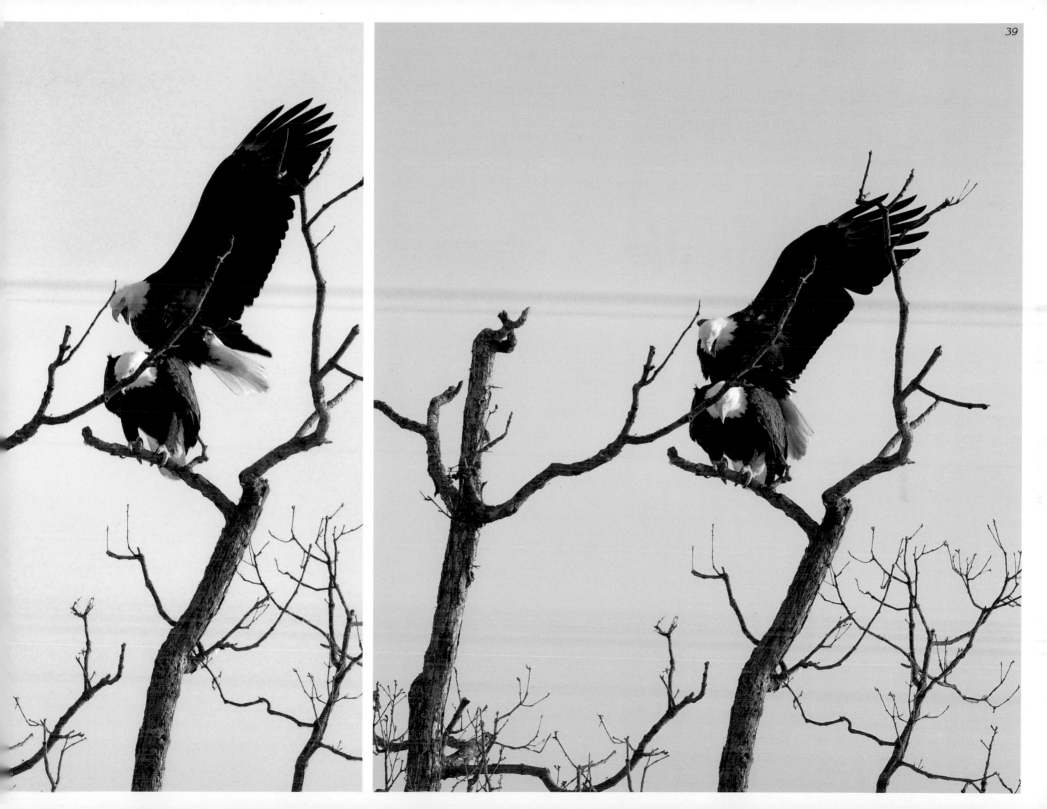

Courtship and mating can last for a few weeks. During this time, the eagles usually visit the nest during the day, but roost in nearby trees at night until it is time for egg-laying. In early February, the female spends an entire night on the nest and lays her first egg. It is white, oval in shape, and measures about 3 inches in length.

To keep the egg warm, the female eagle gently nudges it down inside of the soft cup where it will be cushioned and protected by mounds of dried grasses. However, she might leave it uncovered at times so that full incubation does not begin if she intends to lay additional eggs. Eagles usually lay eggs a few days apart, so partial incubation helps tighten the hatching timeline so the eggs hatch closer together. If the chicks are closer in age, it is easier for the parents to care for their young, and less likely that there will be problems with sibling rivalry or competition for food.

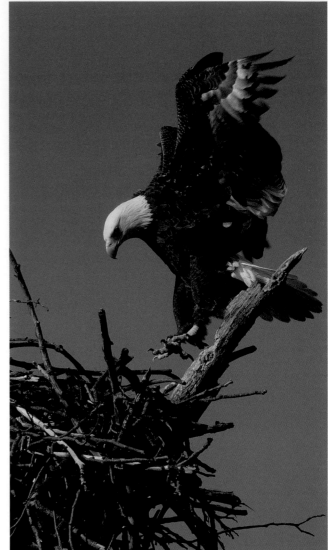

The female returns to the nest to begin laying eggs.

The female lays the first egg of the clutch. *Courtesy of Virginia Department of Game and Inland Fisheries.*

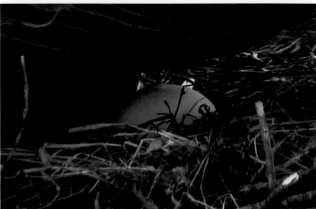

In three days, the female eagle lays a second egg. While bald eagles living in this region lay a clutch of one to three eggs, the most common clutch size is two. While there have been nests in which a fourth egg was laid, it is an extremely rare occurrence.

Three days later, the female lays a third egg and the clutch for this year's nesting season is set at three. The female has now completed egg-laying until next year, unless a problem at the nest causes the eggs to be lost. If the eggs do not hatch, the female might lay a replacement clutch this season.

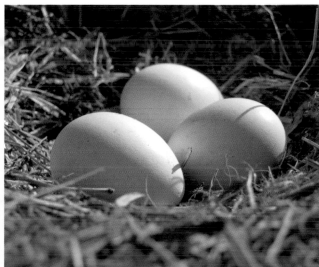

A third egg is laid.

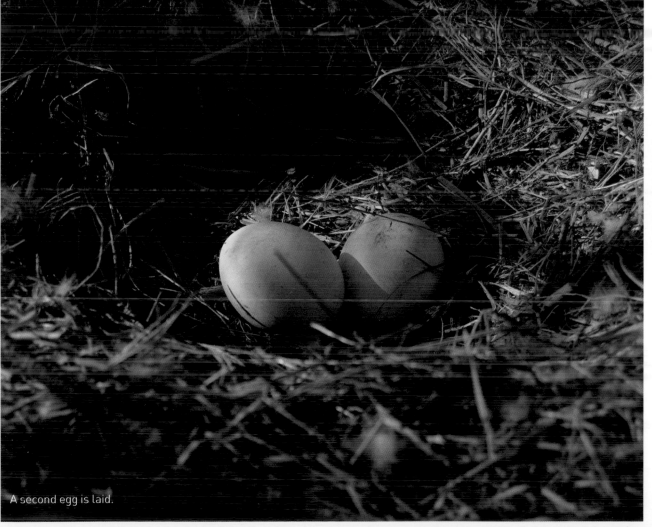

A second egg is laid.

The eggs should hatch in approximately 35 days. Until hatching begins, the eagles will take turns incubating the eggs to keep them warm and dry, although the female does most of the incubating.

To incubate, the adult carefully lowers its body over the cup and gently rocks back and forth into position without stepping on the eggs. With a quick shake, it fluffs its feathers outward like a blanket to cover the cup. The brood patch, a featherless area of skin developed near the parent's stomach, now rests directly on top of the eggs. For extra insulation and to prevent drafts of air from blowing into the egg cup, the parent then uses its beak to adjust dried grasses around its body.

Periodically, the eagle stands and carefully turns the eggs. This prevents the unborn chicks from sticking to the inside of their shells and keeps them evenly warmed. Egg-turning takes skill and care because eagles' feet are powerful and their talons are sharp.

The brood patch, a featherless area near the stomach of both parents, rests directly on the eggs for warmth during incubation.

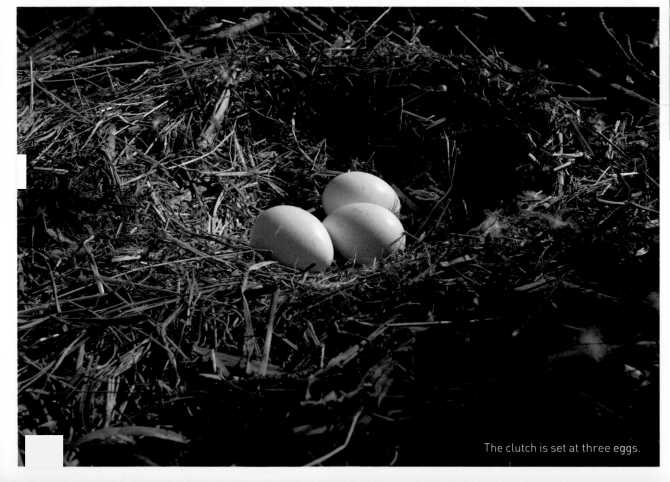

The clutch is set at three eggs.

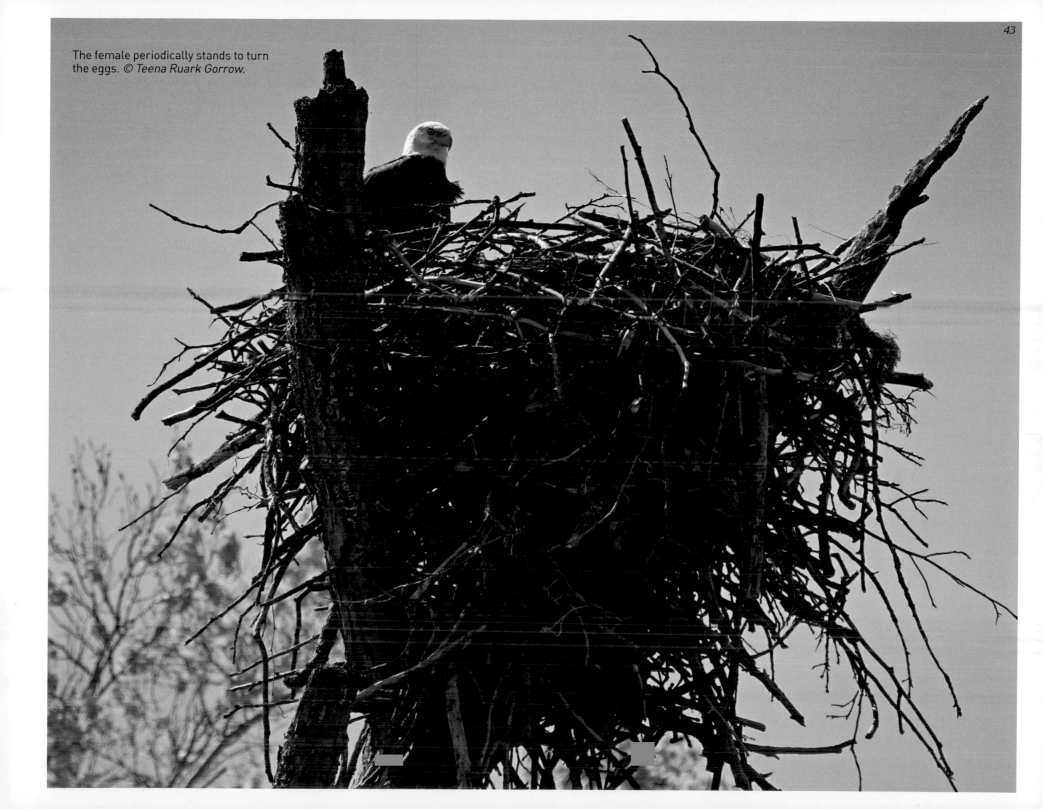

The female periodically stands to turn the eggs. © *Teena Ruark Gorrow*.

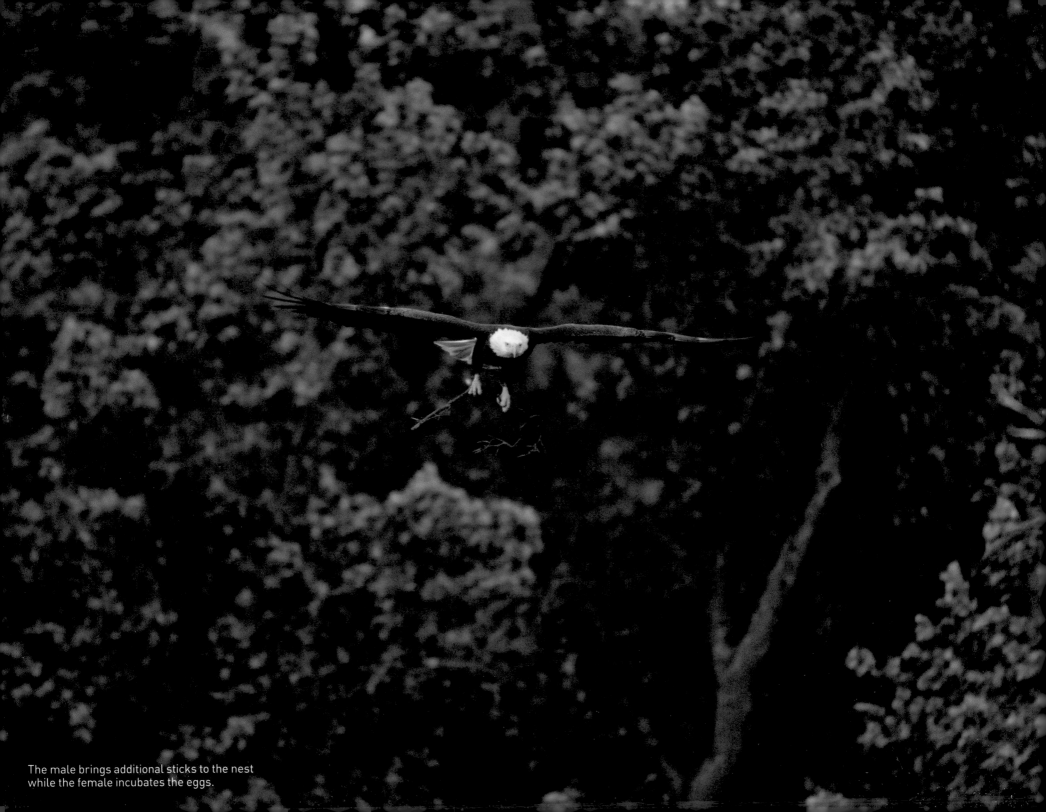

The male brings additional sticks to the nest while the female incubates the eggs.

While the female is incubating the eggs, the male brings additional sticks and grasses to freshen the nest. He also forages prey which he delivers to the nest for the female to eat.

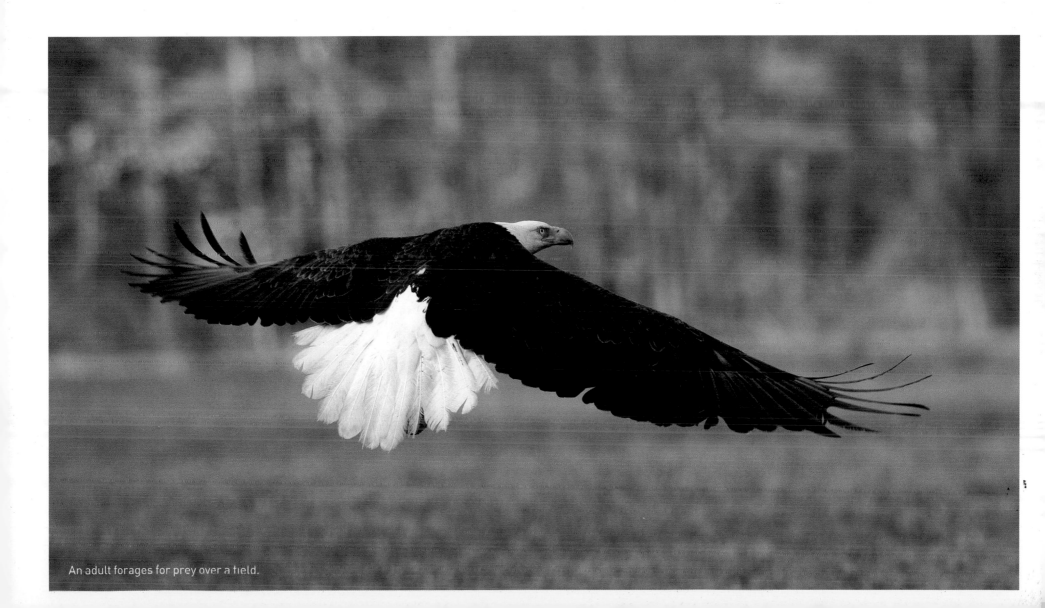

An adult forages for prey over a field.

A skilled hunter with excellent eyesight, the eagle forages while gliding through the air or from a perched position on nearby snags. Balanced on the edge of his lookout, with toes and talons firmly gripping the limb, he patiently waits for movement on the ground or in the water.

While eagles consume a diet of mostly fish, they will feed on other live prey and carrion as the opportunity arises. Muskrats, rabbits, squirrels, snakes, ducks, geese, gulls, and turtles are among the most common prey items foraged by this male and brought to the nest each season.

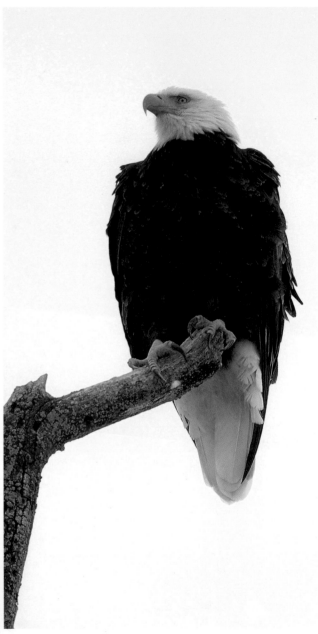

An adult perches on a favorite snag to keep watch for competitors and forage for prey.

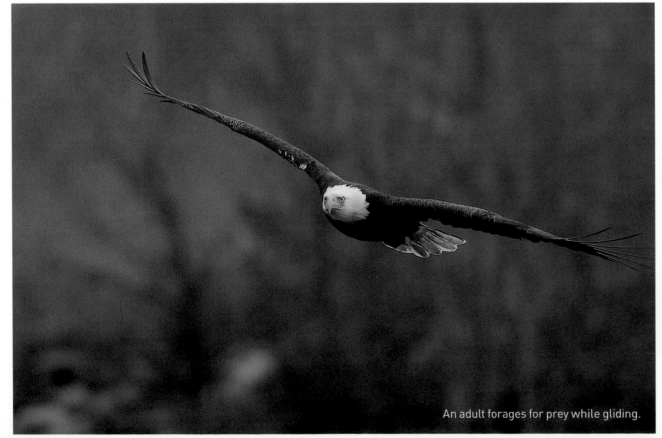

An adult forages for prey while gliding.

When a fish is his target, the intimidating raptor swoops down over the water and positions his powerful feet for the catch. Using his curved talons like hooks, he reaches into the water to snatch the fish. Even with his strength and know-how, it might take more than one try to be successful because the eagle occasionally misses a strike or a struggling fish slips out of its grasp. When this happens, he can usually circle the area and collect the lost prey.

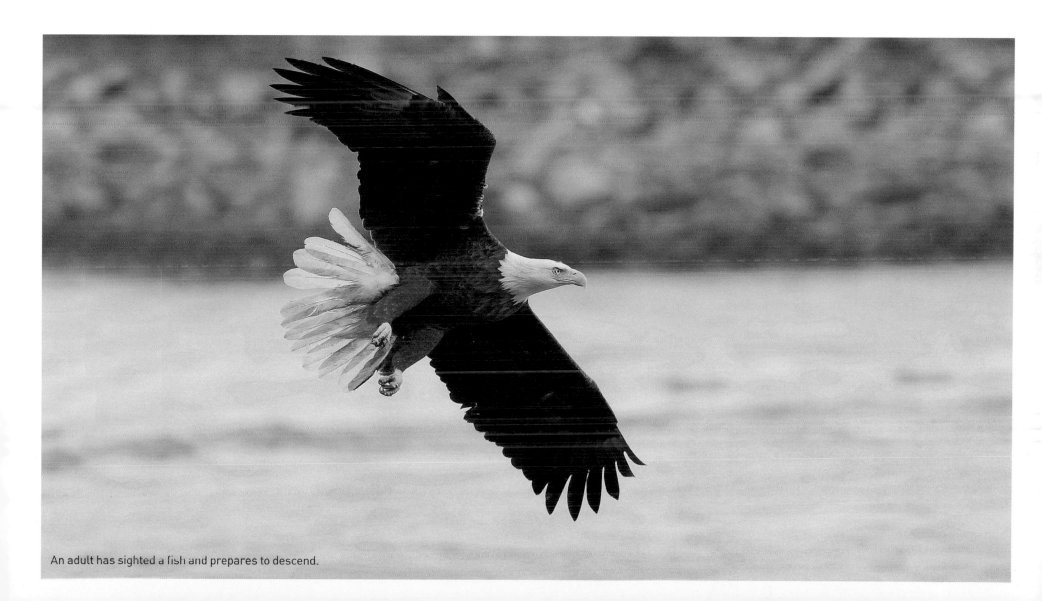

An adult has sighted a fish and prepares to descend.

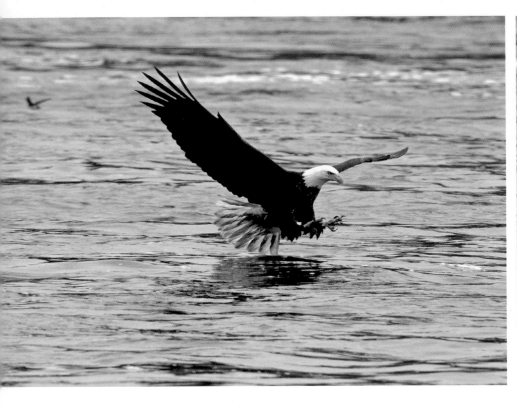
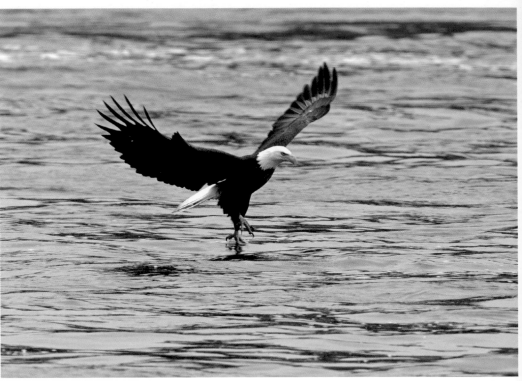

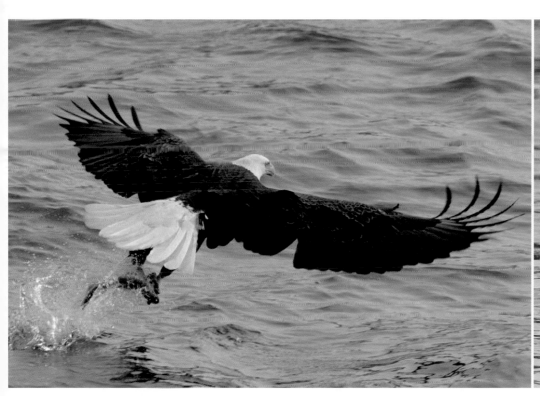
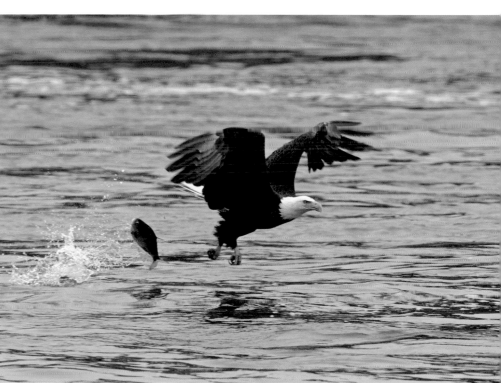

But, the splashing of water during the hunt and the eagle's flight behavior can attract another foraging eagle. Fishing can be hard work and bald eagles are opportunists. To steal an easy meal, the hopeful thief chases the male eagle and flies so close that the wings of both eagles touch. Although the male is gripping the fish with its talons, the attacking eagle grabs and pokes at the prey with its beak and feet. This assault can cause the male to drop the fish. However, this time, the male has a tight hold on the fish and flies back to the nest carrying a meal for the female.

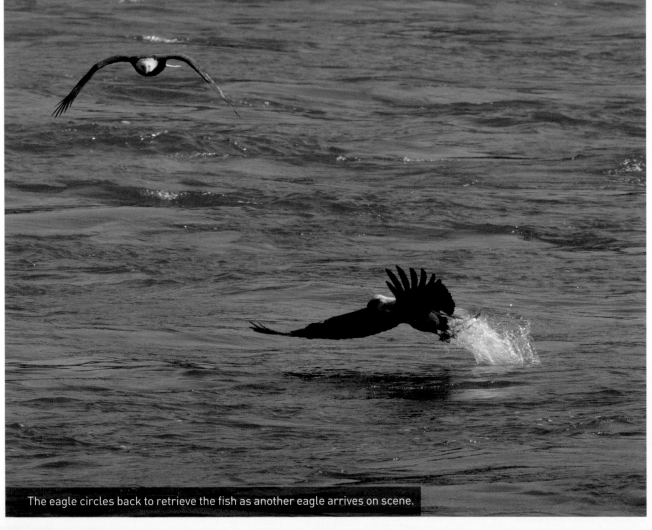

The eagle circles back to retrieve the fish as another eagle arrives on scene.

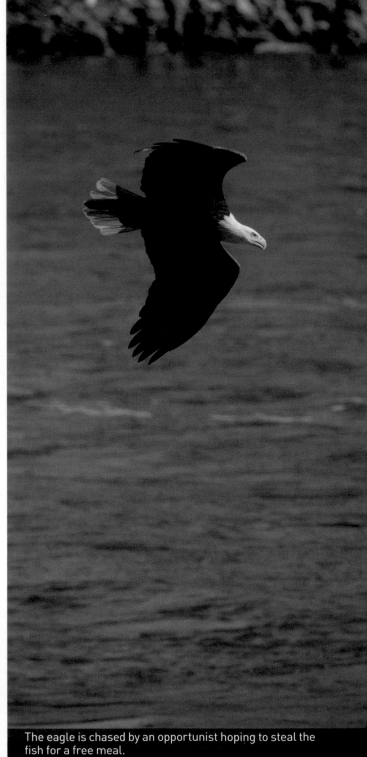

The eagle is chased by an opportunist hoping to steal the fish for a free meal.

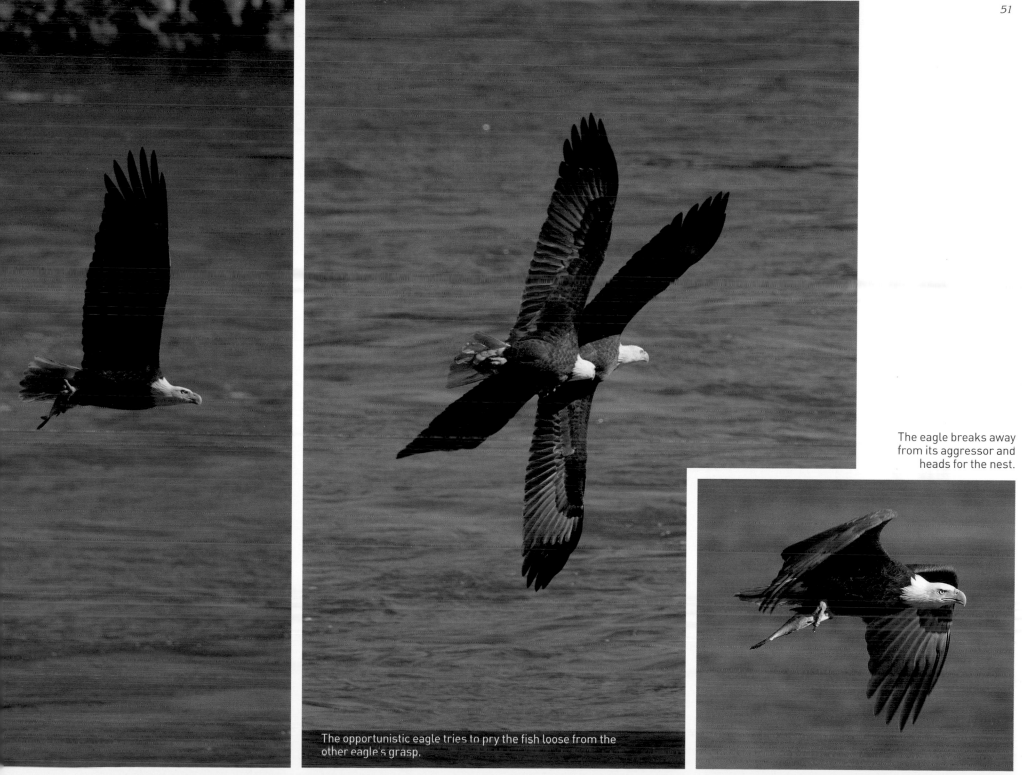

The eagle breaks away from its aggressor and heads for the nest.

The opportunistic eagle tries to pry the fish loose from the other eagle's grasp.

The male regularly checks in with his mate to see if she needs a break from incubating. If so, he will incubate the eggs while she departs the nest to stretch her legs and wings.

When he is not sitting on the nest or hunting for food, the male perches on a nearby branch. He keeps watch over the nest and surrounding territory. The female also watches the nest area and calls to the male if she has any concerns.

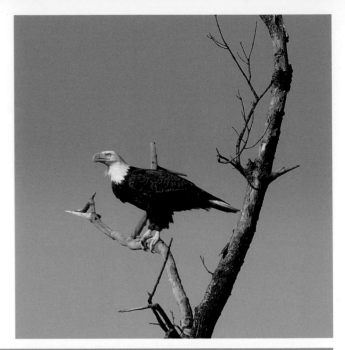

The male perches on a branch near the white oak tree nest.

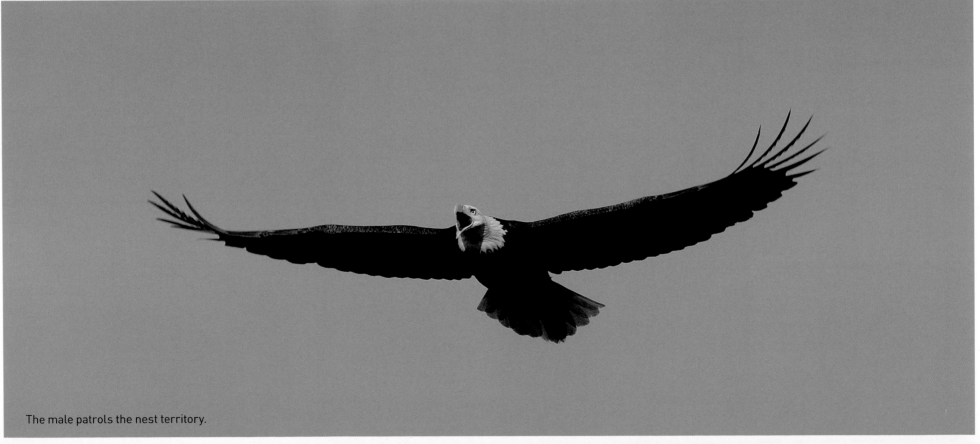

The male patrols the nest territory.

If an intruder gets too close, the male defends the nesting area. Intruders can be other eagles competing for habitat and attempting to take over the nest. Battles for territory can be very dangerous, resulting in serious injury or death. The female will assist her mate in battle only if necessary. Leaving the nest unattended can place the eggs in danger of being harmed by avian scavengers or becoming chilled by cold temperatures which could cause the eggs not to hatch.

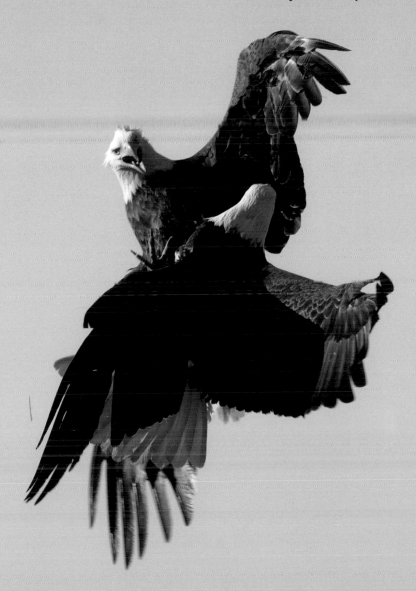

The male defends the nest area from an intruding eagle.

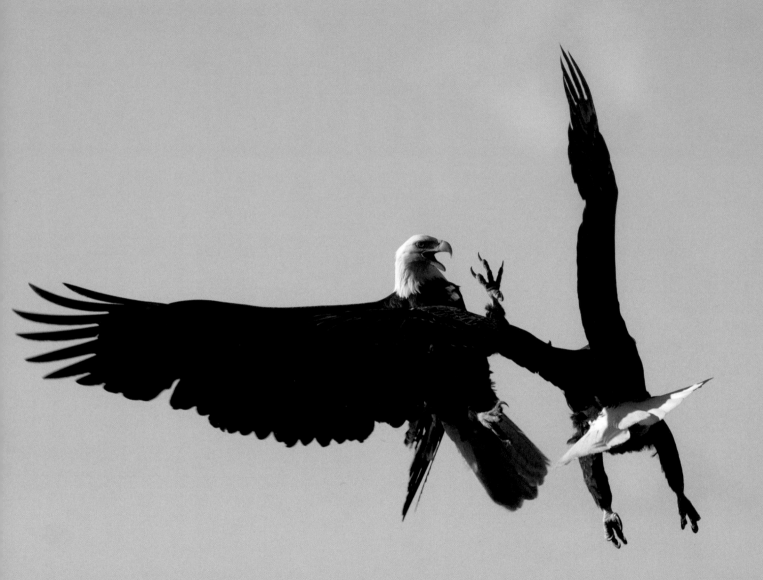

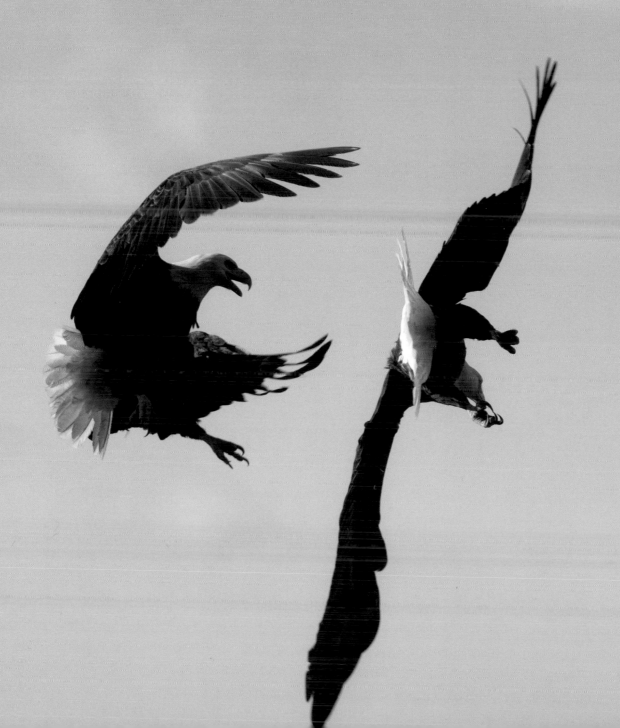

Now March, approximately five weeks after the female started egg-laying, the parent eagles seem to know that their eggs are near hatching. It is likely that they hear soft, high-pitched peeping sounds and feel movement as each chick prepares to hatch. The parents sit higher over the cup while incubating and appear to check the eggs during egg-turning.

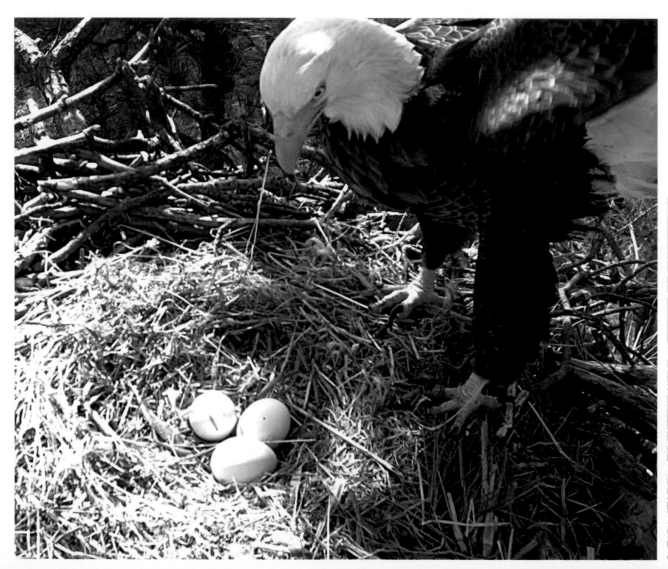

The parent periodically stands to turn the eggs.
© Craig A. Koppie and Teena Ruark Gorrow.

The parent seems to be listening for movement or peeping from inside an egg.
© Craig A. Koppie and Teena Ruark Gorrow.

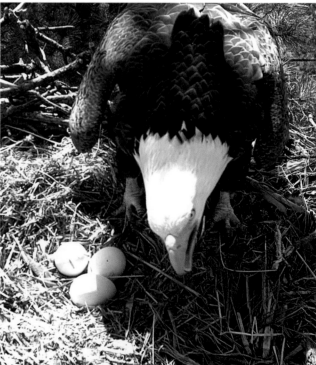

On the inside of the first egg, the chick shifts position and begins using the egg tooth on the end of its beak to peck the shell. This persistent pipping slightly cracks and chips a small hole. It takes a while, but the little chick makes a series of holes side-by-side around the egg, eventually fractures the shell, and breaks free. The tiny hatchling is helpless, tired, and wet.

The parent eagles get a first look at their little eaglet, not yet strong enough to move around or hold up its head. Fine, whitish-gray down covers most of its tiny body like a wet cotton ball. Both eyes are closed slits surrounded by darker shading. At the tip of the little curved beak is the egg tooth which helped the chick hatch from its shell. Nares, or nostrils, rest high on its beak for breathing. There is an opening on each side of its head for hearing, almost hidden by the wet down. The rubbery feet each have four little toes with talons. Slight shoulders and wings, as well as a petite tail, only suggest the large raptor this hatchling will one day become. At just a few ounces, it weighs less than a stick of butter.

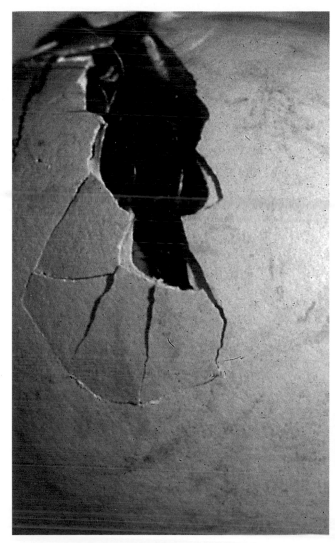

An eaglet initiates pipping. *Courtesy of Sutton Avian Research Center and Stephen Fettig.*

An eaglet breaks free from the egg. *Courtesy of U.S. Fish & Wildlife Service and Dr. James W. Carpenter, College of Veterinary Medicine, Kansas State University.*

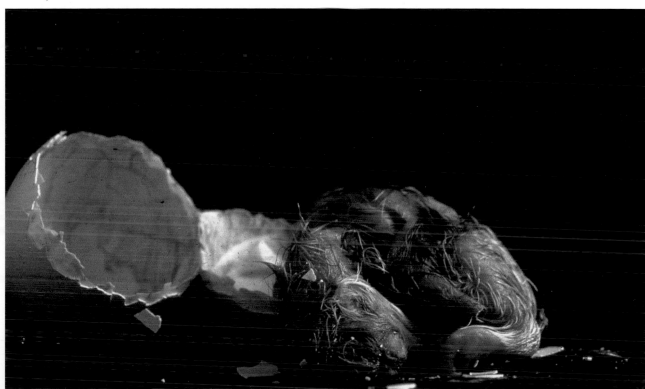

The mother eagle gently covers the baby under her brood patch inside the soft cup for a nap with the eggs. The warmth of her body helps warm the chick and dry its down.

After a while, the father leaves the nest to forage for the baby's first meal. Eaglets generally do not eat immediately after hatching because they have had nourishment from the egg yolk. But, the prey will be available when the chick is ready to take its first bites of food. The mother stays on the nest to care for the nestling and incubate the other two eggs.

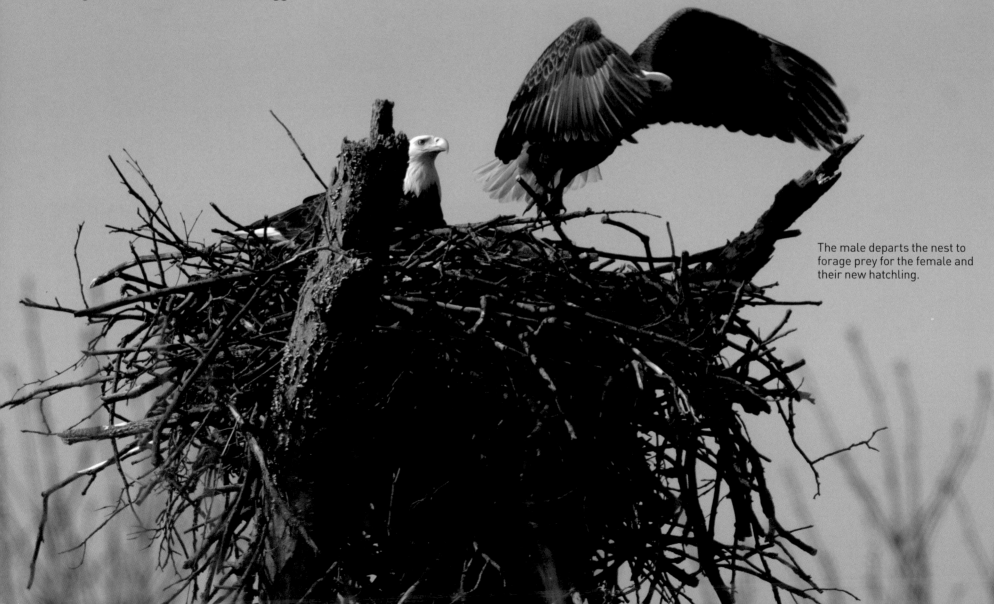

The male departs the nest to forage prey for the female and their new hatchling.

Soon, the father returns to the nest and drops a fresh fish beside the egg cup. The mother stands and moves to the side of the cup to feed her baby. Holding the prey in place with her talons, she rips a piece of flesh away from the bone with her beak. Gently, she leans toward the hatchling's tiny head to offer the morsel of mushy, bone-free fish. Now stirred from napping, the chick bops its little head toward its mother and accepts the food from her beak. After a few bites, the mother repositions her body over the cup and gently tucks the eaglet back under her brood patch to stay warm.

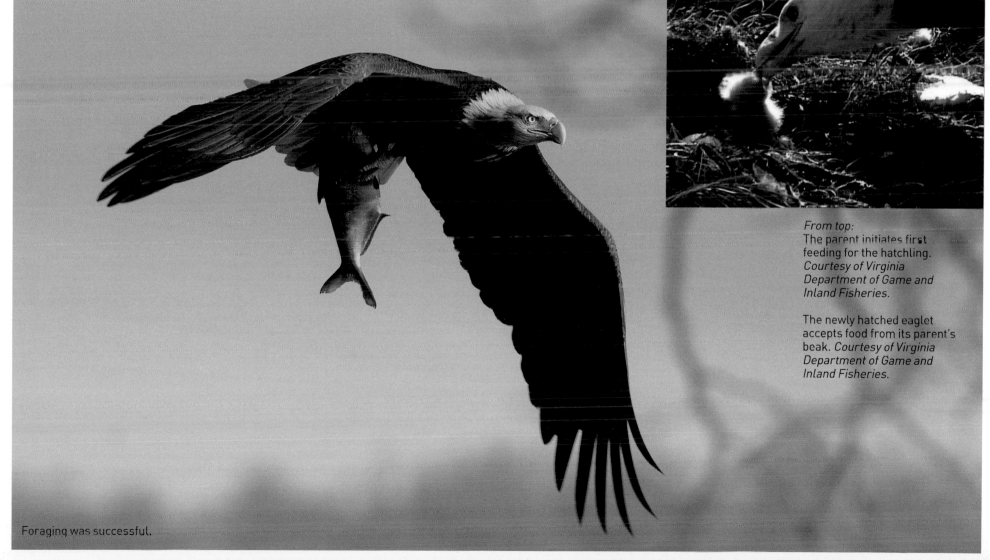

From top:
The parent initiates first feeding for the hatchling. *Courtesy of Virginia Department of Game and Inland Fisheries.*

The newly hatched eaglet accepts food from its parent's beak. *Courtesy of Virginia Department of Game and Inland Fisheries.*

Foraging was successful.

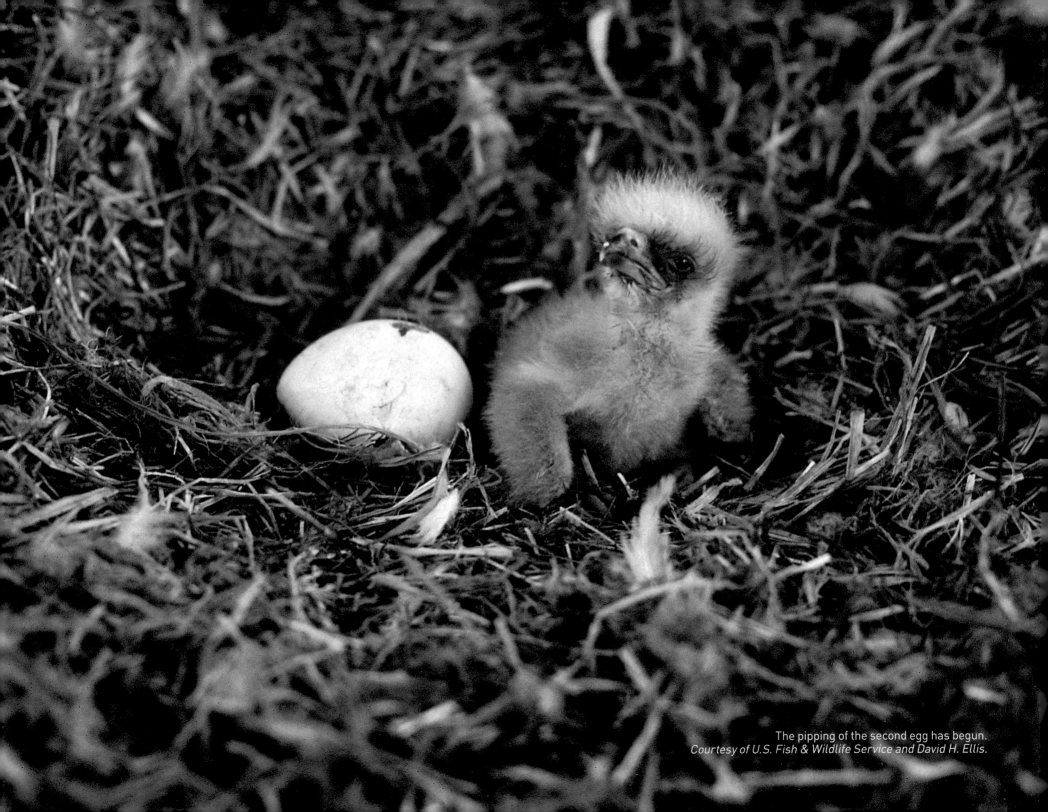

The pipping of the second egg has begun.
Courtesy of U.S. Fish & Wildlife Service and David H. Ellis.

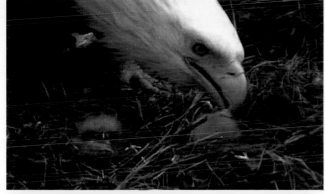

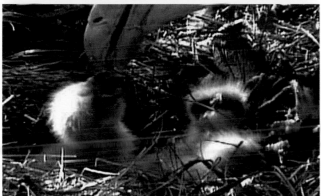

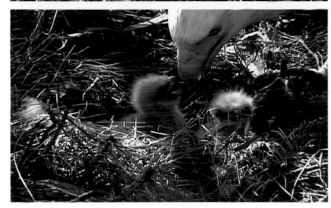

The little nestling is starting to learn about life outside of the shell, but spends most of its time sleeping and resting inside the soft cup alongside the two eggs. Virtually helpless, the baby is dependent on its parents for food, warmth, and protection.

The next day, it hears peeping and a hole appears in the second egg. Soon, the little chick has a new sister or brother. It isn't long before the newborn is ready to eat and the siblings share their first meal together. The mother alternates offering fragments of fish to each youngster. They bop and wobble while reaching toward their mother's beak for food, and sometimes tip over because they lack muscle control. Between feedings, the tiny nestlings snuggle under a parent's brood patch to rest alongside the third egg.

While the mother does most of the brooding, the father keeps watch over their territory and forages for food. He regularly brings fish and other prey to the nest, seemingly aware that it will take quite a bit of food to feed his developing chicks.

Almost two days later, the third egg successfully hatches and the eagle family is complete. The three little eaglets appear to be healthy and doing well. They spend most of their time napping together in the soft egg cup tucked under the brood patch until hunger awakens them for their next feeding. When the mother stands to retrieve bits of fish for their meal, little heads and bodies pop up from the nest cup. The mother is gentle and calm as she places food in her chicks' beaks.

From top:
The parent alternates feeding the two chicks. *Courtesy of Virginia Department of Game and Inland Fisheries.*

And then there were three! *Courtesy of Virginia Department of Game and Inland Fisheries.*

The parent eagle gently places a morsel of fish in the eaglet's beak. *Courtesy of Virginia Department of Game and Inland Fisheries.*

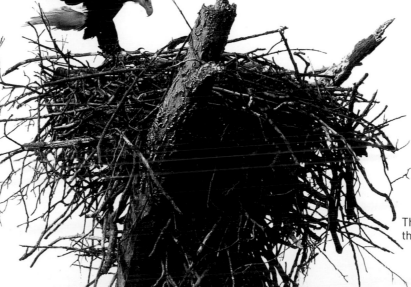

The father eagle delivers a fresh fish to the nest for the eaglets' next meal.

When the parents switch places so the mother can stretch her wings, an inside peek into the nursery reveals that all three chicks are strong and growing. They appear to be content and their full crops suggest that they are being well fed. The fluffy babes curl on their sides or flop on their bellies to sleep, and rest their heads on tufts of dried grasses at the edge of the egg cup. If a chick rolls over, stretches, or moves to expel waste away from the sleeping quarters, the others merely raise their heads and plop back down to resume napping. In fact, sleeping is such a popular pastime for these young birds that they occasionally skip a feeding. They move about by swaying their little bodies and wings because they do not yet have the strength or coordination to stand.

The eaglets are content after consuming a meal of muskrat.

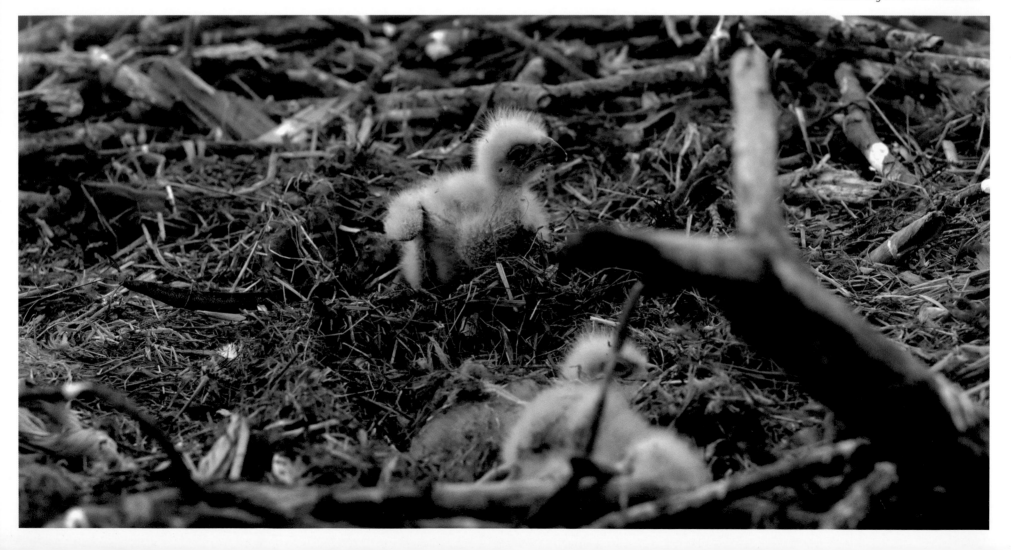

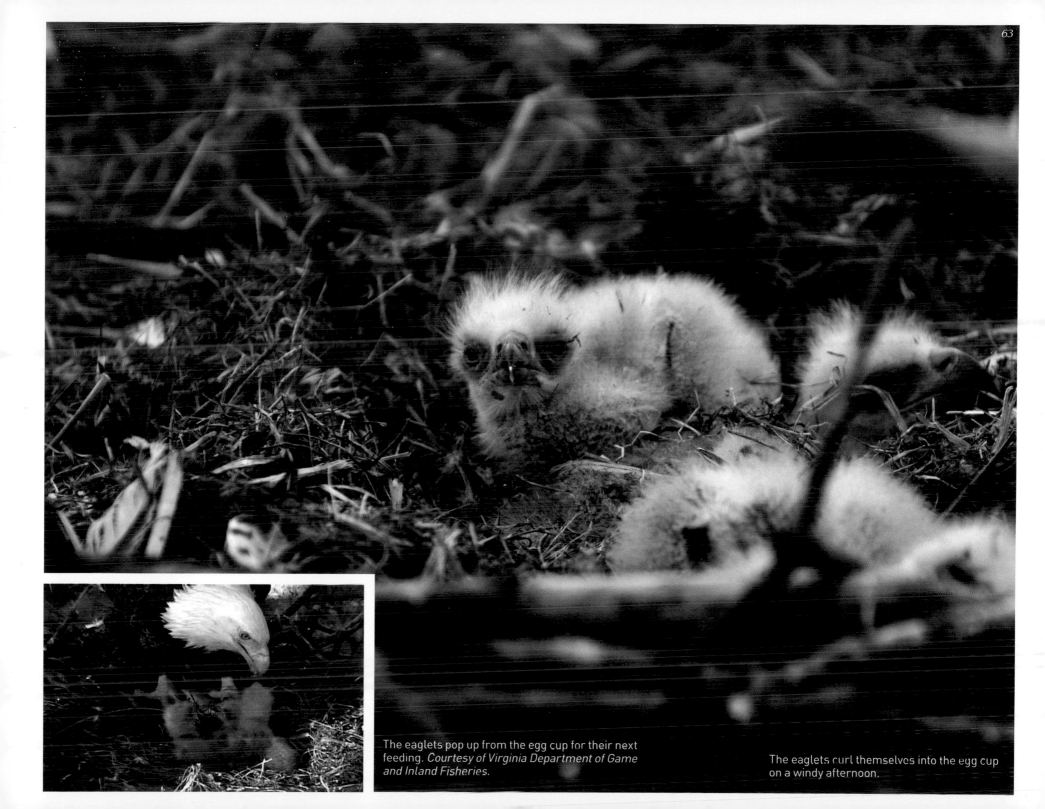

The eaglets pop up from the egg cup for their next feeding. *Courtesy of Virginia Department of Game and Inland Fisheries.*

The eaglets curl themselves into the egg cup on a windy afternoon.

The nestlings are noticeably larger and seem stronger as they approach two weeks of age. While they can now sit in an upright position and hold up their heads for longer periods of time, they often lay forward on their bellies, especially when their crops are full. Still not able to stand or walk, they crawl on their tarsi to move around the egg cup. Other appearance changes include a less distinctive egg tooth as it becomes absorbed into the upper part of the beak, and more fully opened eyes. First down plumage is being replaced by a second coat of down which is a darker shade of gray.

Daily activities still include mostly sleeping and eating. At mealtime, the chicks line up near their mother in the egg cup and wait to be fed. While some nestlings become aggressive during feedings, with the largest eaglet killing its siblings as early as the first week after hatching, these orderly eaglets take turns accepting the food offered by their mother. However, the babies do sometimes bop each other as they reach upward toward their mother's beak for the tasty morsels of meat.

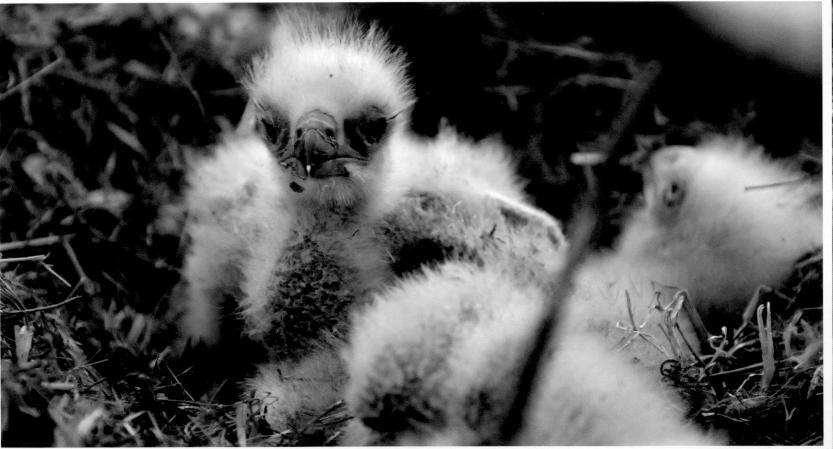

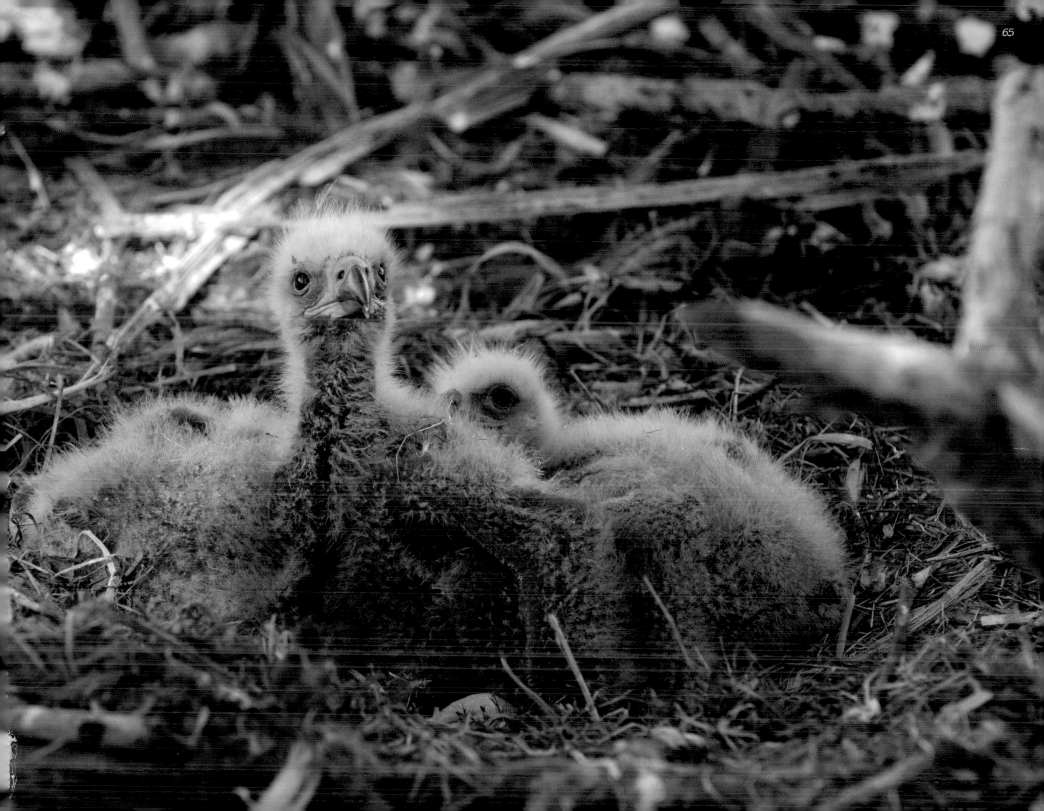

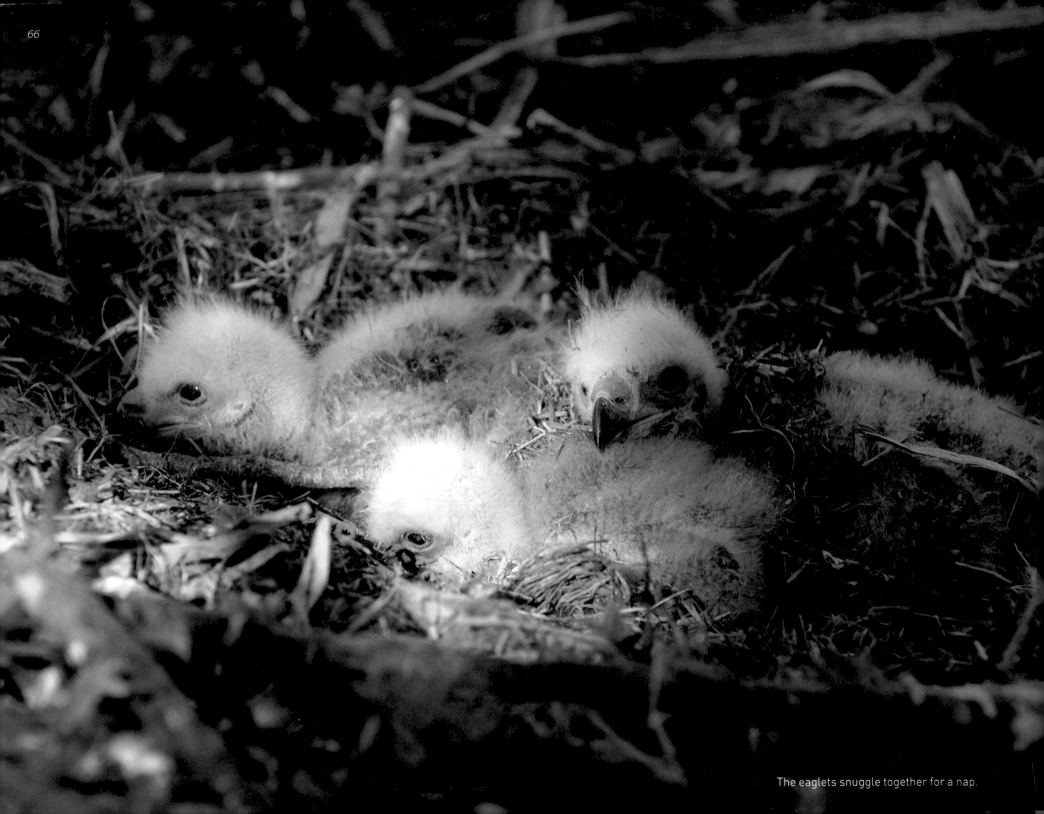

The eaglets snuggle together for a nap.

The three-week old nestlings are continuing to grow in size with more elongated heads, and their down is a darker shade of gray. They no longer need brooding as long as the weather is mild because they are now able to retain body heat.

The sounds of food-begging and chirping echo beyond the nest as the babies cry to their parents for another feeding. It takes more and more prey to satisfy the hungry appetites of three growing youngsters, which requires the father to forage often. While both parents sometimes feed the eaglets, the father usually flies away after dropping off prey and straightening the nest.

When the father brings prey, the eaglets scoot closer to the food. While food competition can create sibling rivalry should feedings become less frequent, aggressive behavior is still not a concern at this nest. Food deliveries are numerous, there is plenty to eat, and all three chicks are being fed. Once they have eaten, the chicks quickly plop on their bellies and stretch out for their naps.

The powerful beaks of eagles make it possible to consume turtles which are brought to the nest as prey.

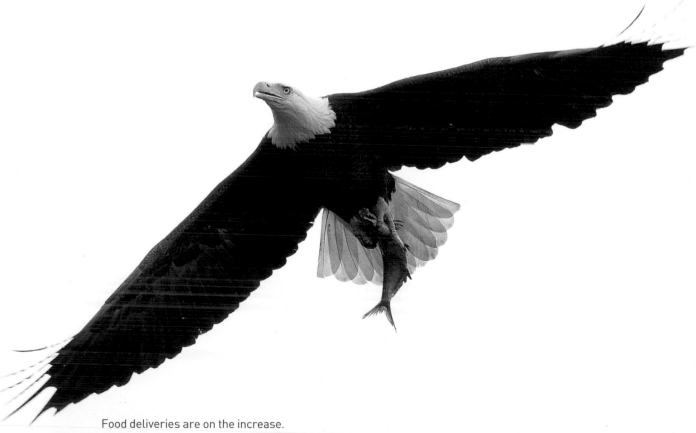

Food deliveries are on the increase.

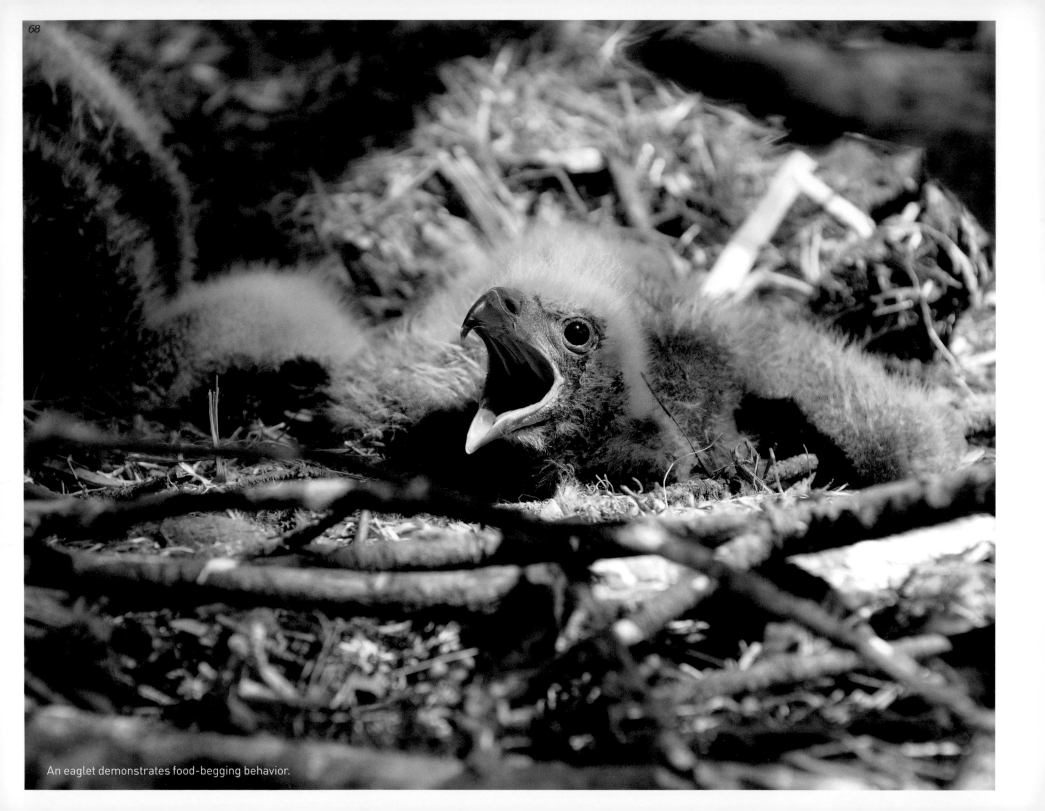

An eaglet demonstrates food-begging behavior.

Eaglets spend a considerable amount of time plopped on their bellies.

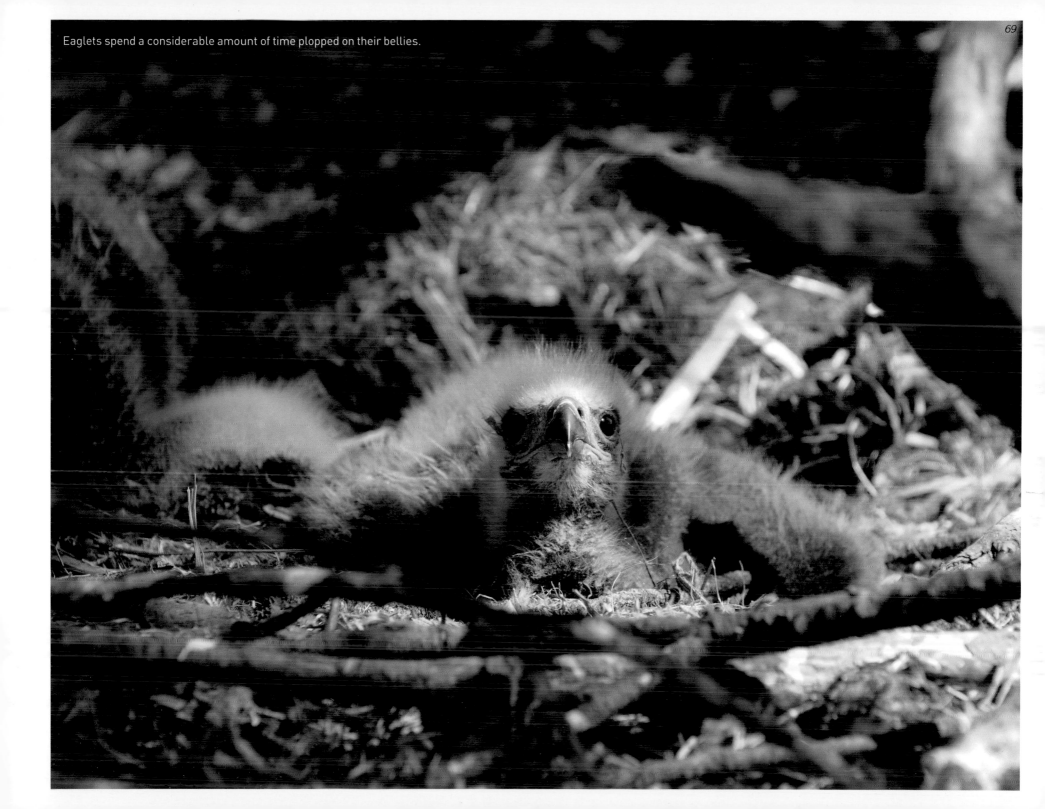

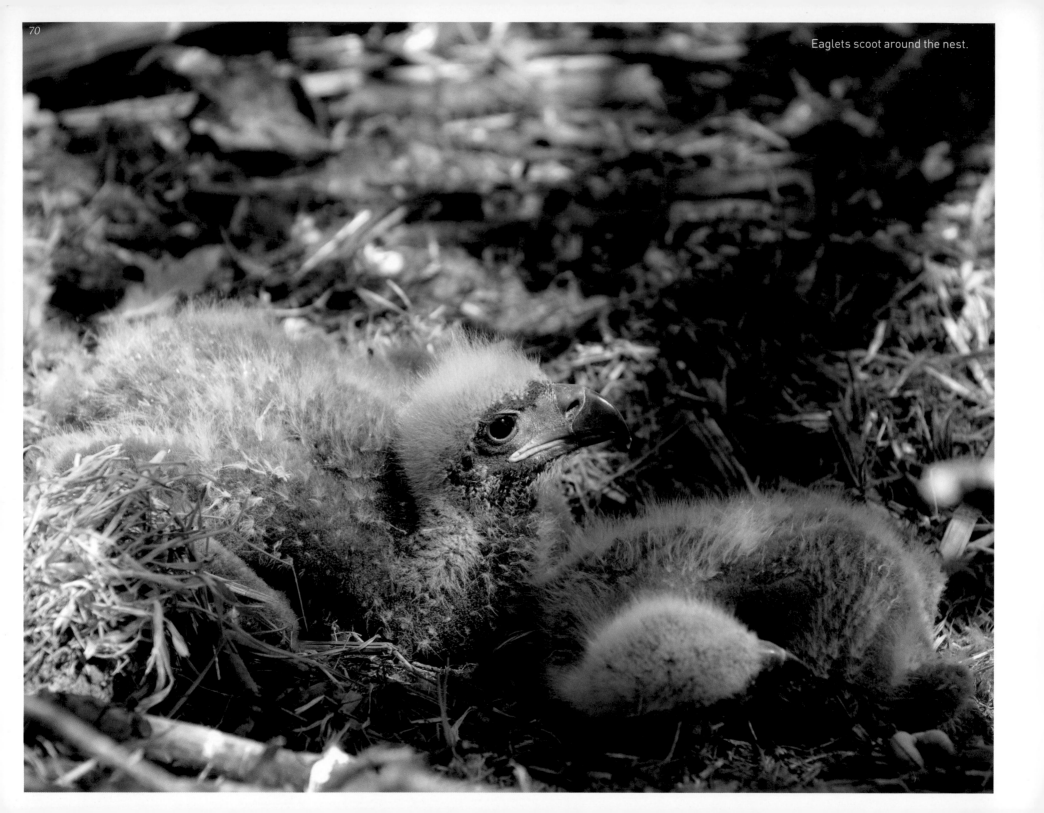

Eaglets scoot around the nest.

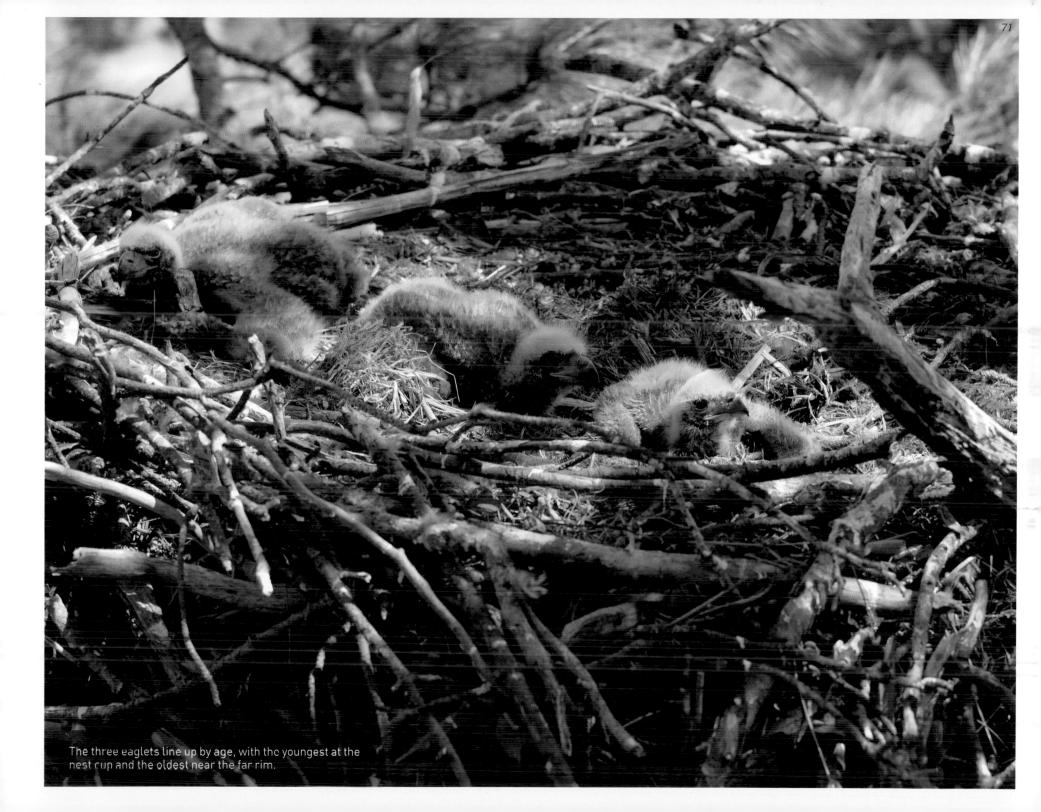

The three eaglets line up by age, with the youngest at the nest cup and the oldest near the far rim.

Because there are no branches above their nest in the white oak, the eaglets are in open view with no protection from the elements. On hot spring days, as the sun beats down on their growing bodies, the young birds can overheat due to warm temperatures and the insulation from their down. They pant with mouths wide open to release body heat, and huddle in the shade of tree limbs which support the nest. They lie down on their chests with wings outstretched along the nest rim and heads hanging over the nest to catch a breeze stirring from beneath the tree.

Although a parent eagle remains nearby, an adult is not always sitting on the nest now that the eaglets are older and do not need brooding. But, if a parent is on the nest during warm temperatures, the eaglets will seek refuge under the adult's outstretched wings. This is also true in the case of a spring snow or sleet event during which the parent will shelter the babies with its shoulders and wings.

The parents carefully monitor changes in temperature. Just before dark on an unseasonably cold night in April, the mother eagle made several trips to nearby fields for additional dried grasses and straw. Upon return, she hovered over the 4-week old nestlings and placed the straw on their backs like a blanket, as if to tuck them in for the night.

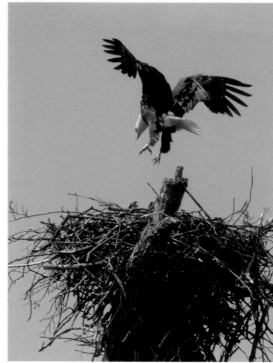

A parent returns to the nest to shelter the eaglets from the sun.

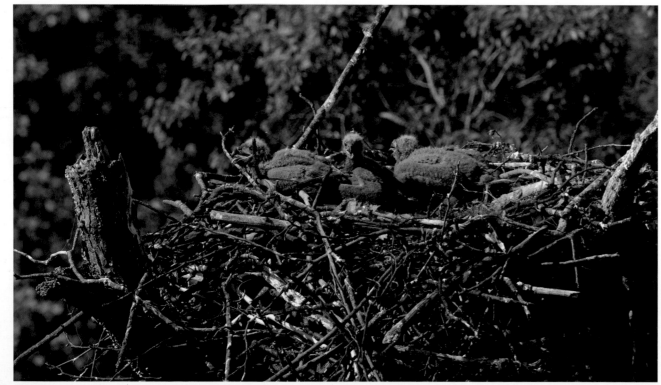

The eaglets pant sitting in the direct sunlight of a warm April morning.

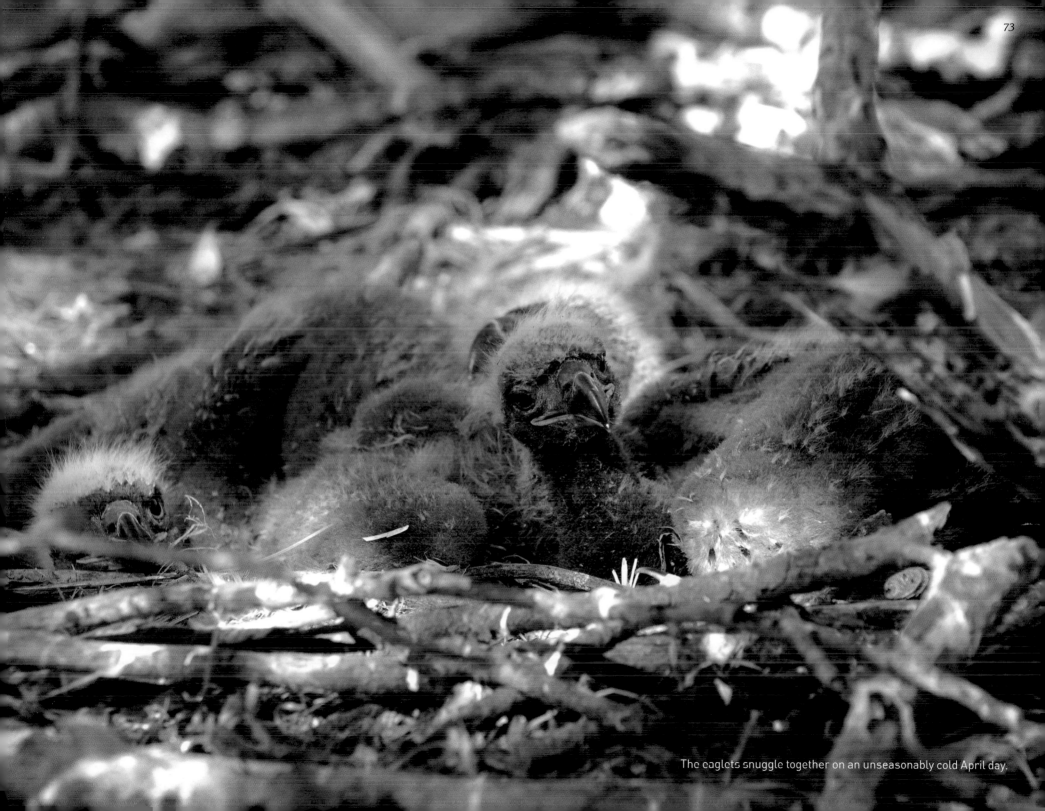

The eaglets snuggle together on an unseasonably cold April day.

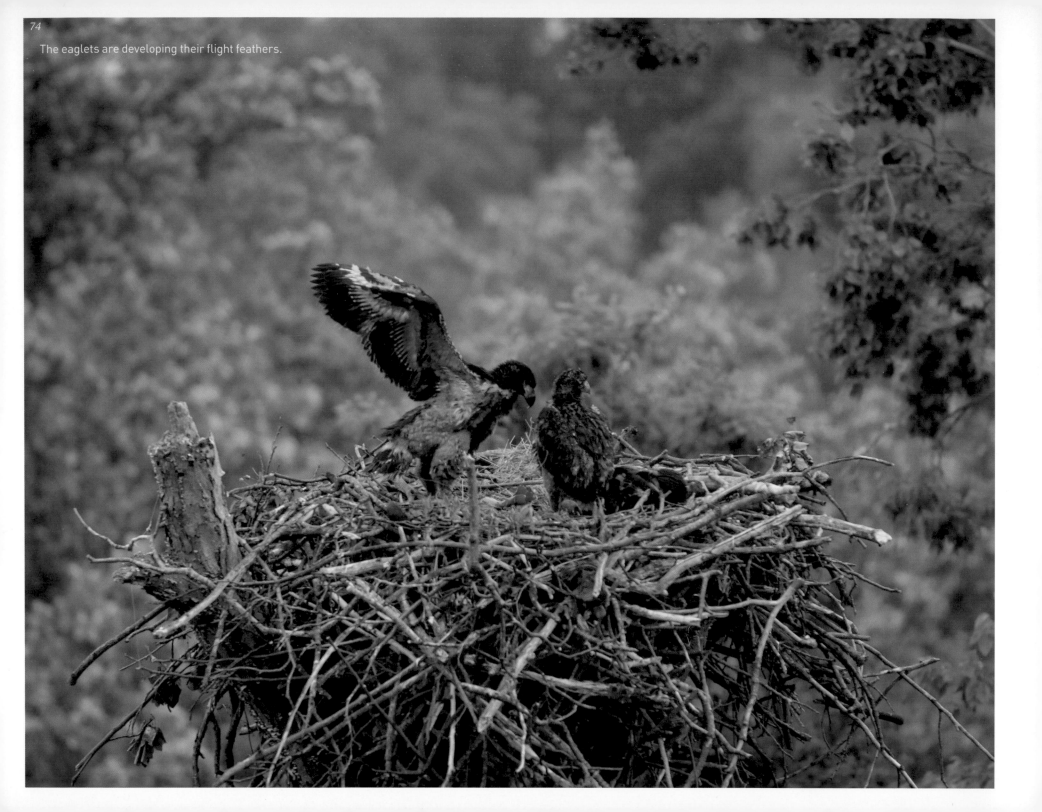

The eaglets are developing their flight feathers.

Around five weeks old, the eaglets' feather shafts, or quills, are very noticeable and appear blue as the blood supplies and nourishes the feather follicles. New feathers are growing from the exposed shafts and look like small paint brush tips.

The eaglets' beaks are wider and longer with a more pronounced downward-curved point. Their yellow, scaled legs and soft, rubber-like feet have also grown and look large when compared to the rest of their bodies. Although their appearance may look somewhat threatening to an intruder, they have little body muscle at six weeks of age, which makes their talons ineffective for protection.

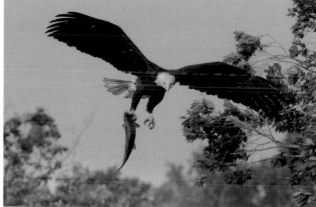

A parent delivers yet another fish to the nest.

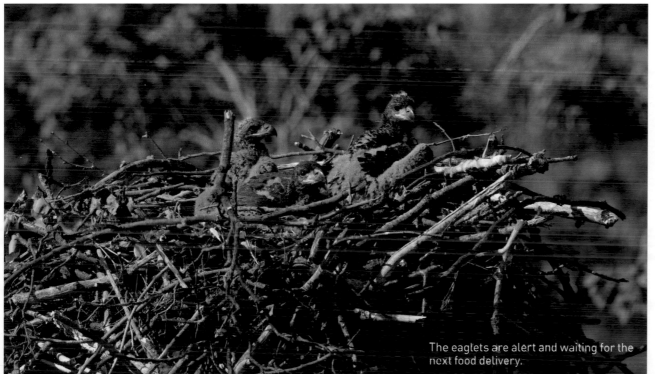

The eaglets are alert and waiting for the next food delivery.

An eaglet plays with a pinecone.

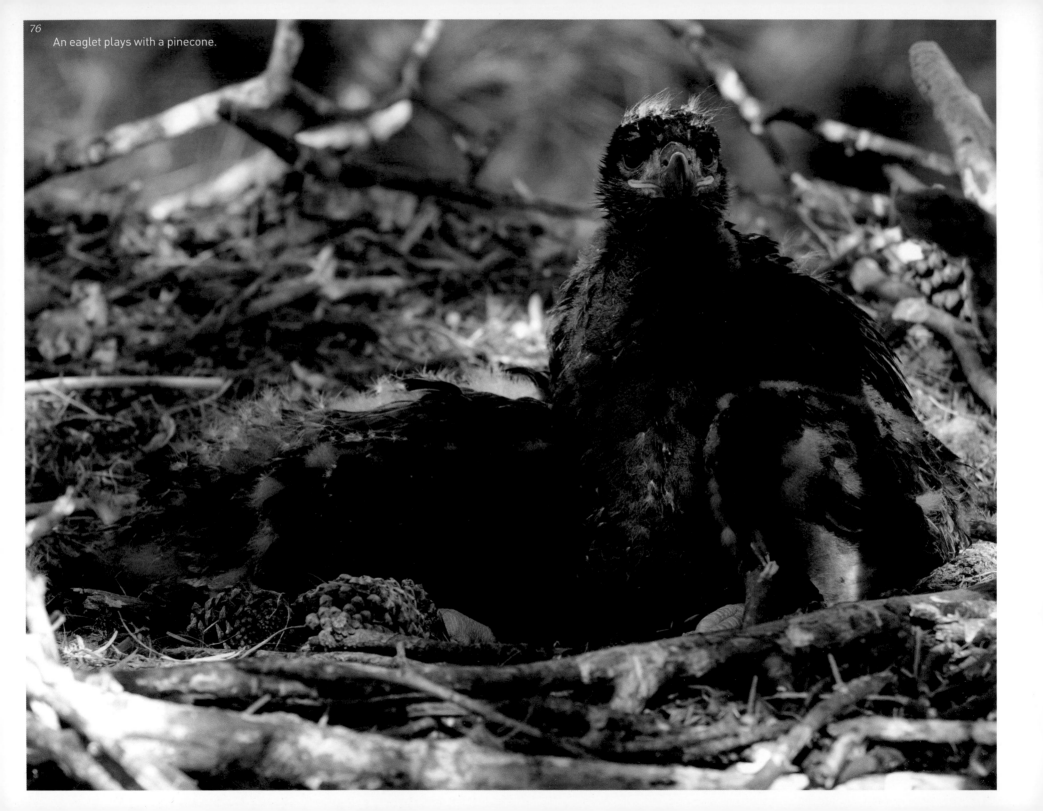

These young birds are alert and intently watch the world around them. They seem somewhat playful as they look for things to do inside the nest. With their beaks, they lift, bite, and drop pinecones. They also push the pinecones with their feet and talons. If one eaglet pulls on a stick or some dried grass, the others circle around and watch with wonder. Each wants to join in the fun, waiting for a turn to play with the items being used as toys.

The mother and father eagles are spending more time away from the nest and perching in nearby trees. The eaglets sometimes vocalize, or stand to welcome a parent back to the nest, especially if the return includes an item of prey.

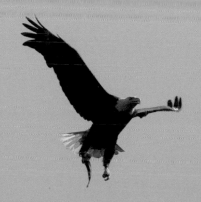

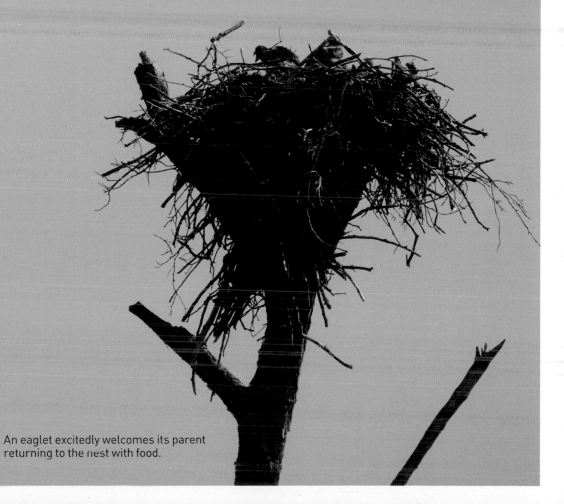

An eaglet excitedly welcomes its parent returning to the nest with food.

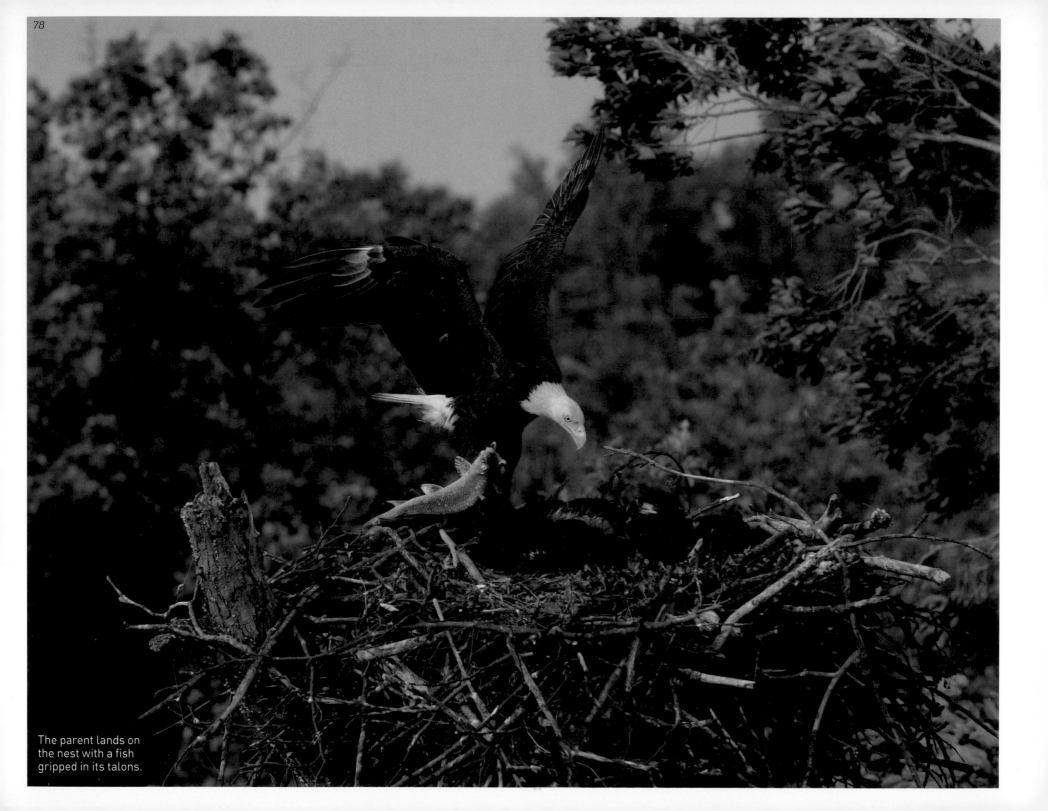

The parent lands on the nest with a fish gripped in its talons.

The parents take turns delivering food to the nest. Although a bit clumsy, the eaglets are starting to tear at the prey to feed themselves. They will soon learn their parents' trick of holding the fish in place with their talons. They will also learn the art of consuming the fish from head to tail, starting with the head.

Around seven weeks of age, the eaglets are standing and walking across the nest platform. They have almost achieved their full growth, and their plumage is now a very dark shade of brownish-black.

An eaglet experiences its first coordinated attempt to stand and eat without parental assistance.

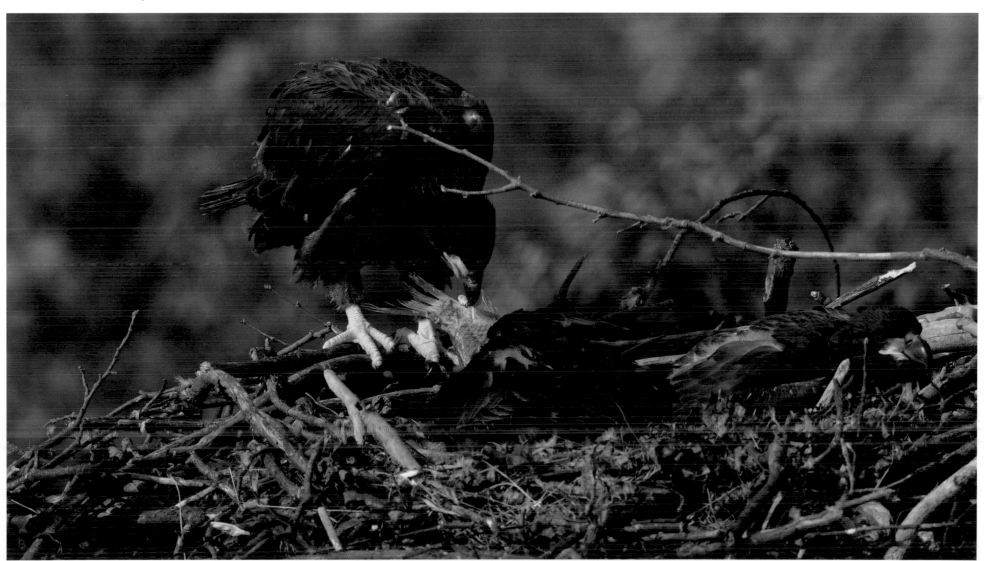

One rainy morning in early May, the mother makes a few trips to the nest with mounds of dried grasses and straw clasped in her talons. Two of the eaglets move, allowing their mother space to land and arrange the grasses. Not paying attention, the youngest eaglet blocks the busy mom's effort. After straightening the nest around the baby, she places a pile of straw on its back, lifts her wings, and flies away from the nest. While her reasons for this particular act are unknown, it is conceivable that the straw on the back of the youngster was a gesture of playfulness or even a reprimand. In a short while, the mother eagle returns with sticks and tidies the nest. Then, she delivers another fish and brings greenery before leaving the young birds on their own for a few hours.

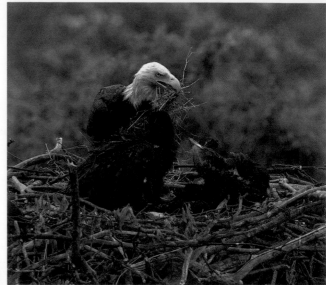

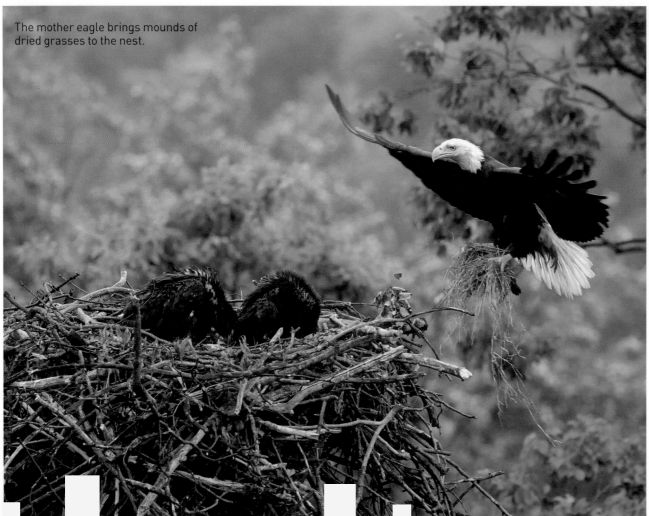

The mother eagle brings mounds of dried grasses to the nest.

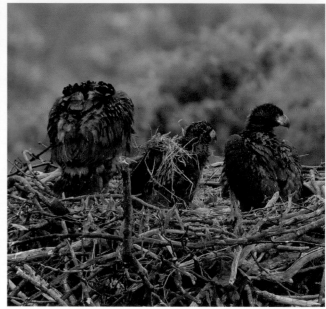

From top:
The mother arranges the dried grasses inside the nest.

Dried grass rests on the back of the youngest eaglet, having been placed there by its mother.

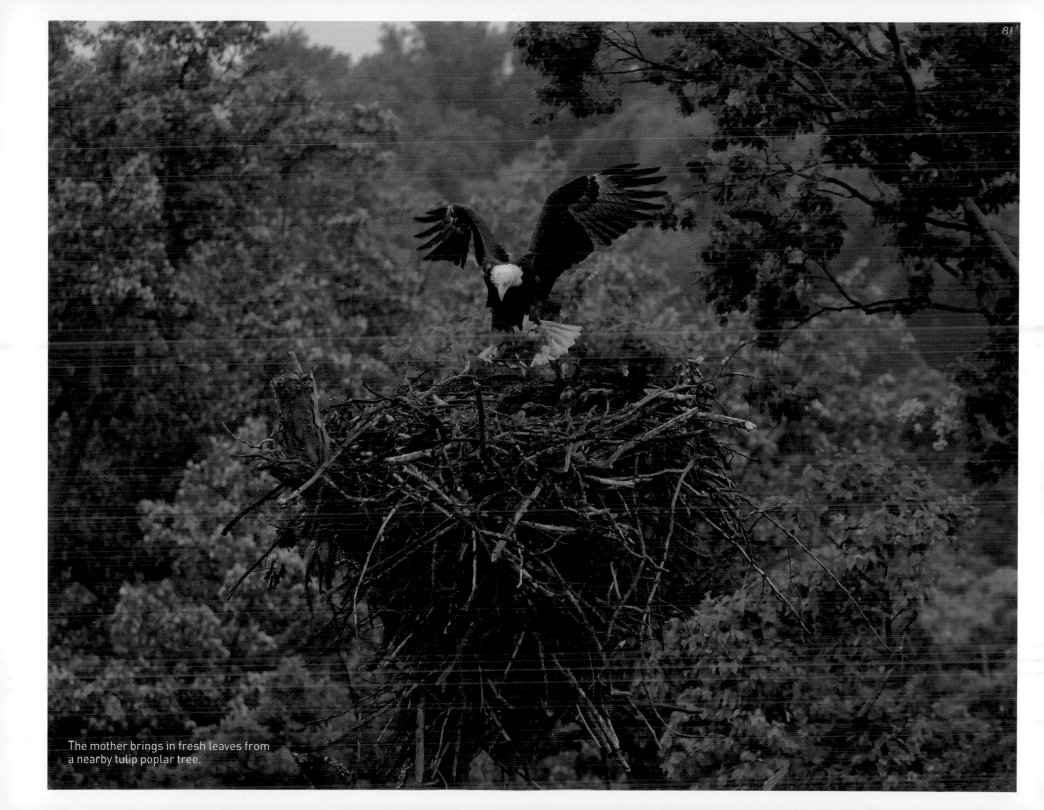

The mother brings in fresh leaves from
a nearby tulip poplar tree.

During weeks eight to ten, the eaglets are particularly interested in flight. They intently watch their parents patrol territory around the nest and seem captivated by songbirds fluttering about in search of insects. Larger birds, like vultures, osprey, and other bald eagles, also capture the nestlings' attention. A sub-adult eagle occasionally conducts fly-bys to check out the siblings and a juvenile eagle attempts landing on the nest. But, the protective parents do not tolerate intruders. When a bird flies too close to the youngsters, the parent eagles vocalize and quickly chase it away.

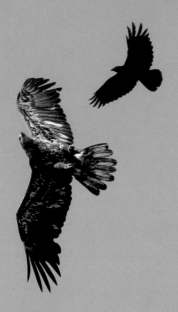

A songbird visits the nest in search of insects.

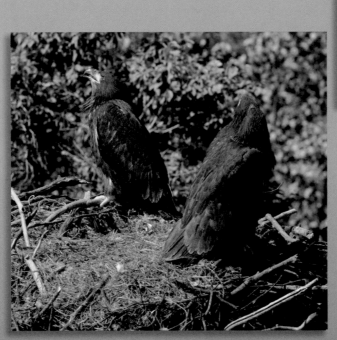

A sub-adult eagle, being harassed by a common crow, invades the aerial space above the nest.

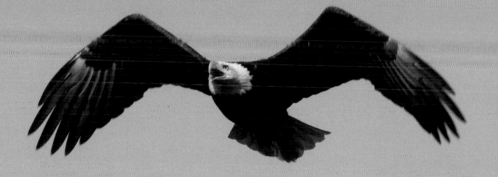

The father issues a warning to an intruder flying too close
to the young.

The young birds also devote their attention to preening and rearranging out-of-place feathers. Using oil from a gland near the base of the tail, they coat their feathers to repel water and keep in body heat.

The eaglets' main flight or pin feathers look similar to those of their parents, but they will not achieve white head and tail feathers until they become mature at four or five years of age. They have learned how to effectively hold prey with their beaks and feet while eating, but they still accept food from a willing parent's beak.

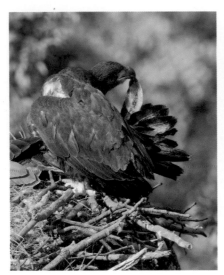
An eaglet preens its feathers.

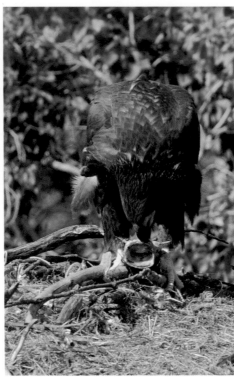
An eaglet has mastered holding and tearing its prey.

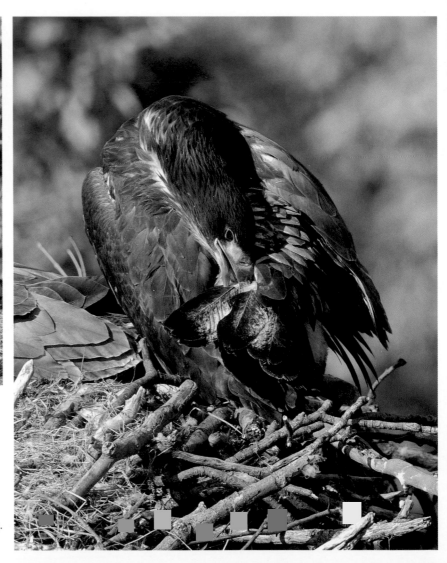

An eaglet continues preening.

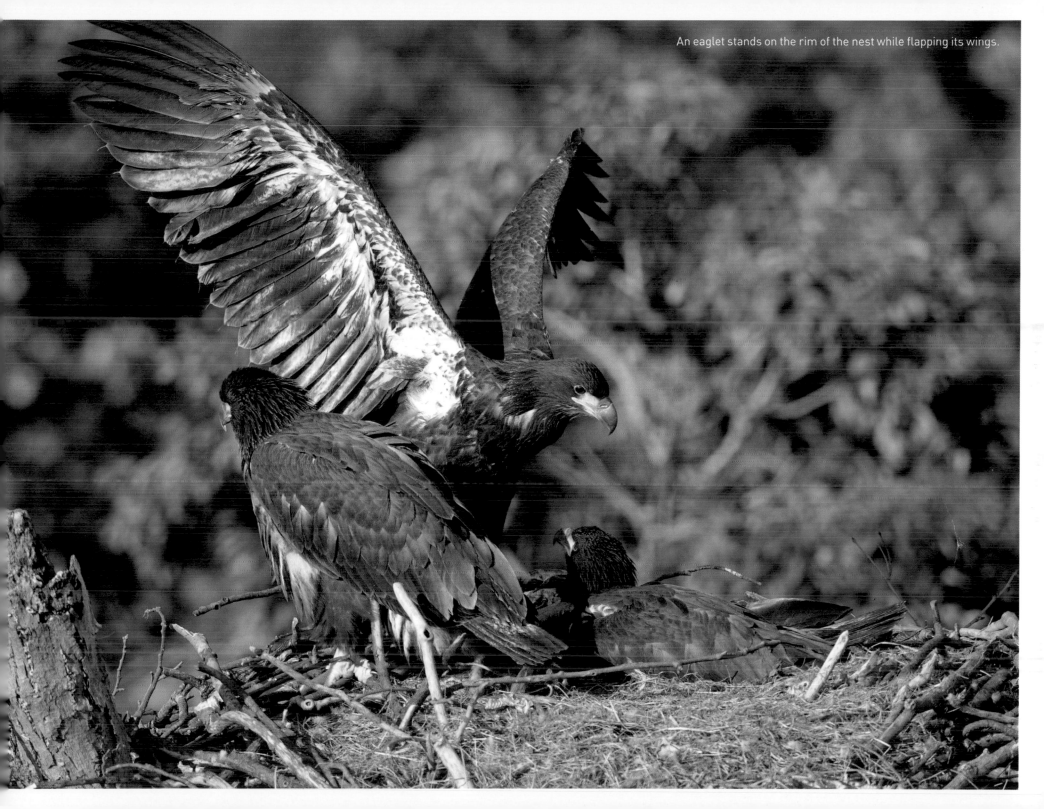

Extremely lively, the ten-week old eaglets are looking for things to do inside the nest. Pecking and balancing sticks in their beaks has become a favorite pastime. They stretch, flap their wings, and jump about in the nest. Wing-flapping helps build wing muscles and hopping helps build leg muscles.

With little spare room to even stand, it is becoming more difficult for the nestlings to exercise their wings in the nest without bumping each other. They hold tightly to the nest with their feet, while flapping their wings with fierce determination. Gaining confidence, the eaglets release their grip while flapping. Momentarily airborne, they hover slightly above the nest. This nest hovering behavior is the first step toward flight. Soon, the eaglets will fly.

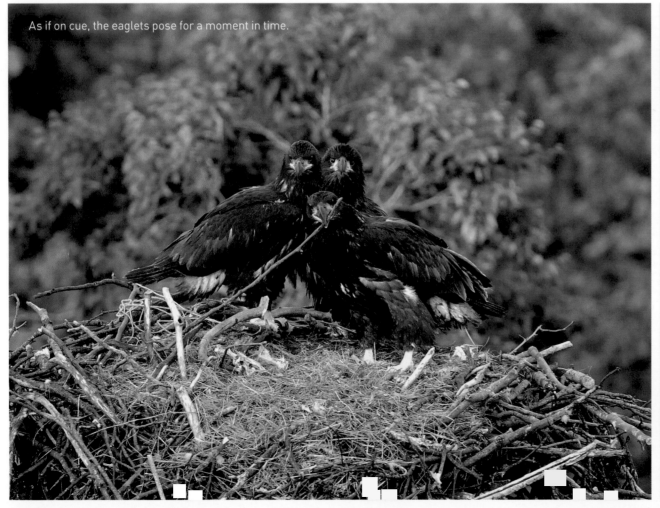

As if on cue, the eaglets pose for a moment in time.

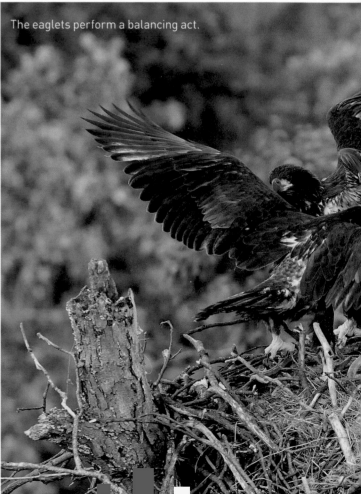

The eaglets perform a balancing act.

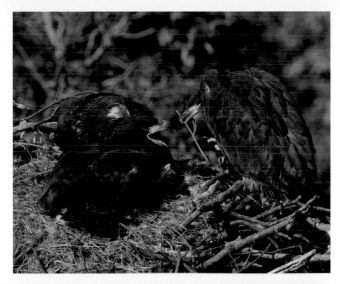

The eaglets seem to be engaged in conversation as they huddle together and toy with sticks.

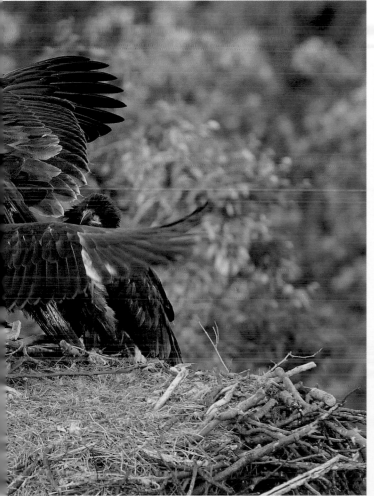

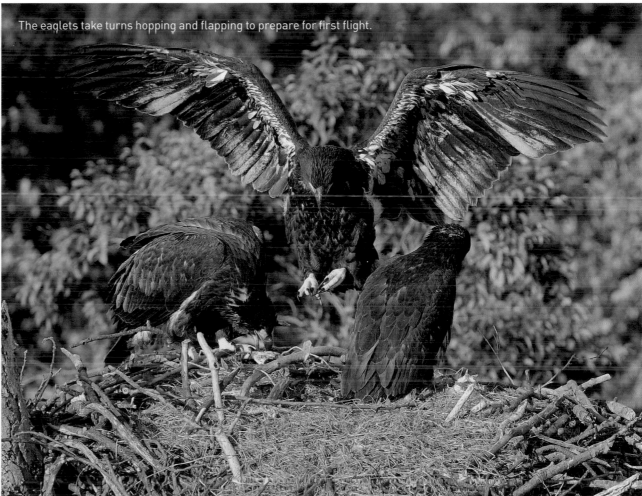

The eaglets take turns hopping and flapping to prepare for first flight.

When limbs are available above a nest, eaglets eventually branch by hopping and flapping to horizontal limbs near the nest. But, the limbs above the white oak nest have decayed and fallen away, now reduced to just a few feet above the nest's rim. Nonetheless, these determined siblings take turns hopping and flapping on the supporting limbs sticking out above the nest.

The initial attempts to perch can be challenging for the young eaglets. They must learn to grasp the limbs with their talons while balancing their body weight. It takes practice over a number of days before the young eaglets will have the strength and endurance to perch away from the nest.

By the eleventh week after hatching, wing exercises and muscle development have prepared the nestlings for their first flights away from the nest. It becomes readily apparent that a flight event is about to unfold as an eaglet looks out over the horizon, perhaps studying the surrounding landmarks and considering a flight plan. It begins head-bobbing and positions its wings tightly against the sides of its body to initiate a launching procedure. In one quick maneuver, it crouches low, springs outward using its legs, and lifts its wings capturing air to propel from the nest. Leaving the nest was successful! The eaglet is flying.

At first, the young bird is awkward with the use of its large wings, but quickly identifies a few basic maneuvers to sustain flight. The eaglet tentatively glances back toward the nest. Perhaps the eaglet is in need of reassurance from its siblings, or is marking territory from its newfound perspective above the nest.

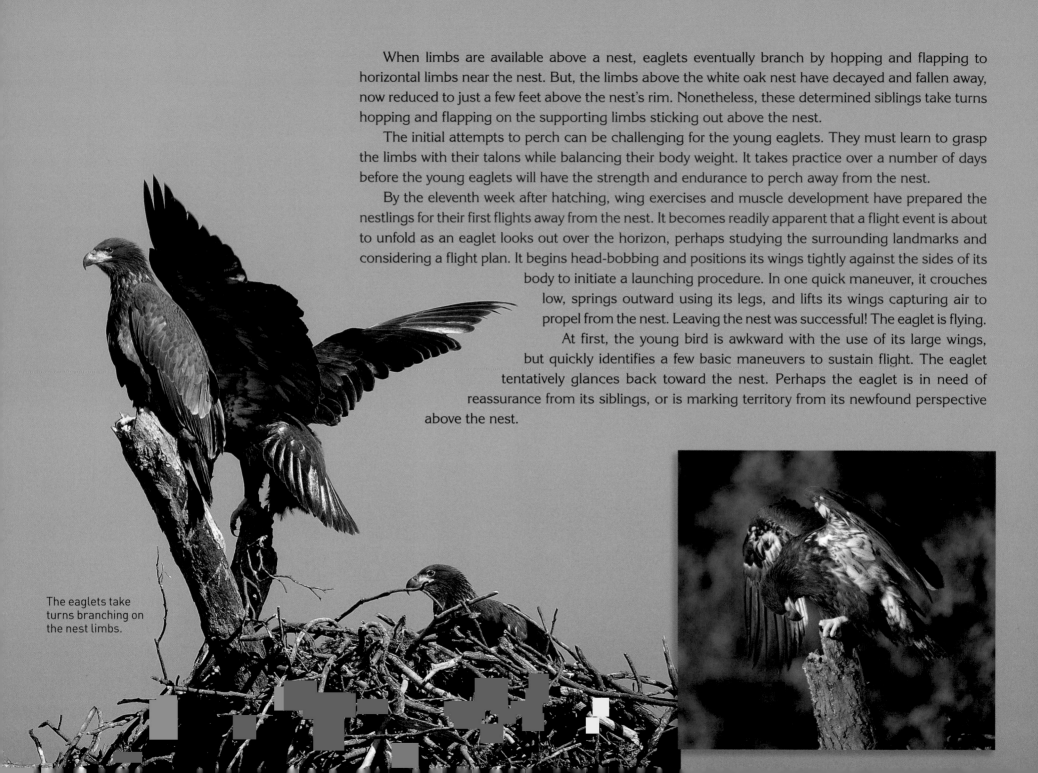

The eaglets take turns branching on the nest limbs.

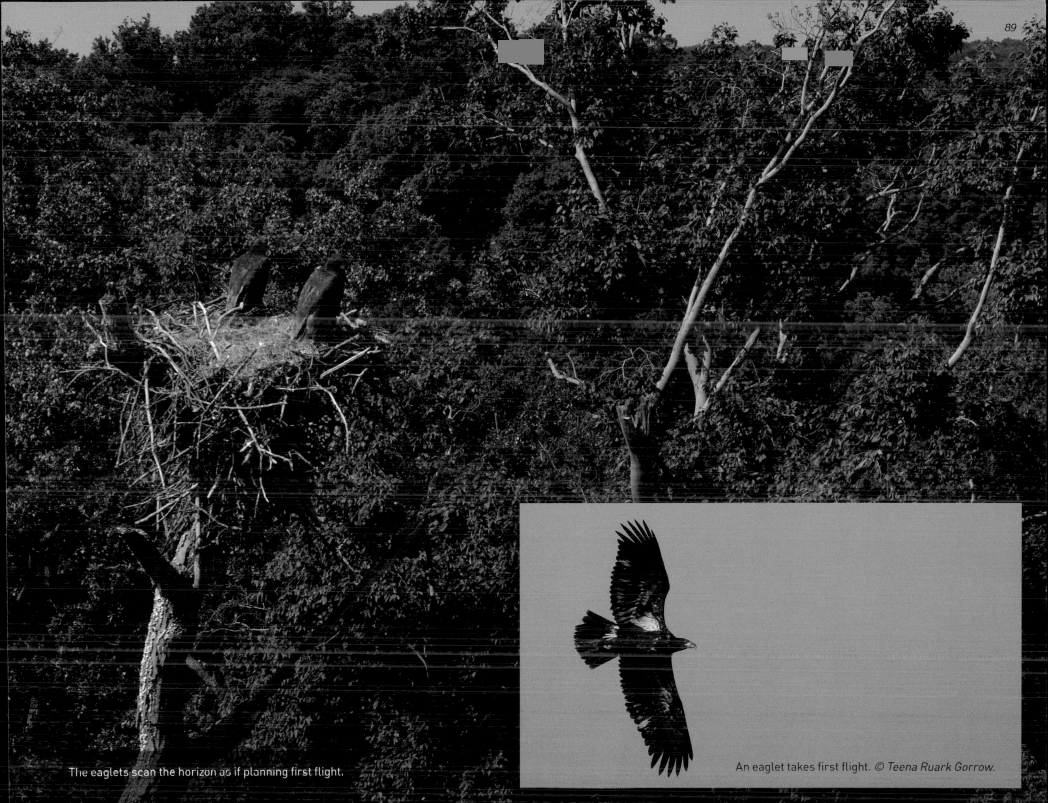

The eaglets scan the horizon as if planning first flight.

An eaglet takes first flight. © *Teena Ruark Gorrow.*

The initial flight lasts just a few minutes and the eaglet now approaches a return to the nest under the watchful eyes of its curious siblings. As common in first-flight landings, the tentative bird is not sure-footed because the methods to slow down have not yet been learned. Nonetheless, the eaglet is successful with the touchdown, albeit gawky, and lands safely.

Learning to fly requires skill and the young eagle will need practice. Many eaglets are seriously injured or do not survive their first flights. Happily, that is not the case at the white oak nest.

Soon, each sibling experiences success leaving and returning to the nest. Just twelve weeks after the eaglets hatched, all have fledged. They fly higher and farther away with each flight, often perching on the branches of nearby trees. Their practice is complemented by improved flying and landing skills, as well as increased stamina while clasping tree limbs and maintaining balance. One June afternoon, two of the playful siblings clamor for the same branch.

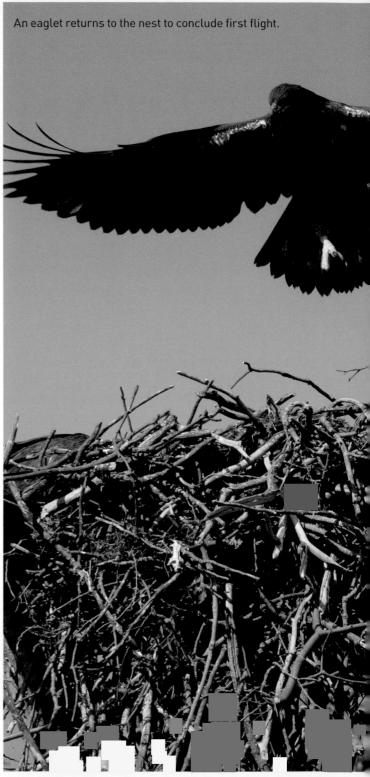
An eaglet returns to the nest to conclude first flight.

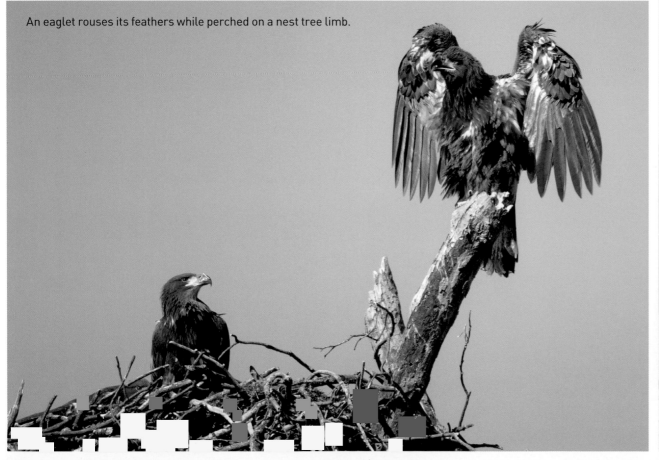
An eaglet rouses its feathers while perched on a nest tree limb.

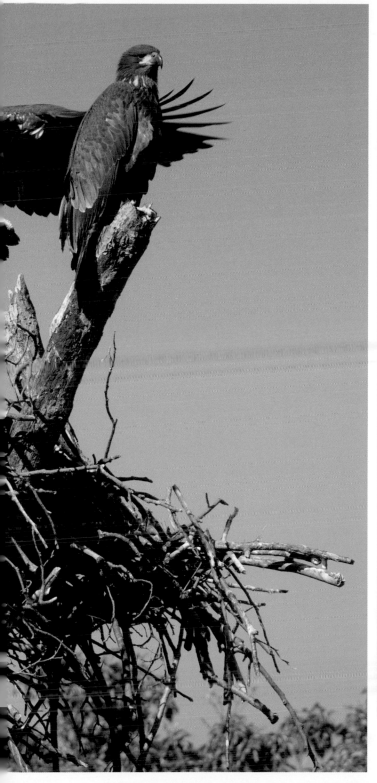

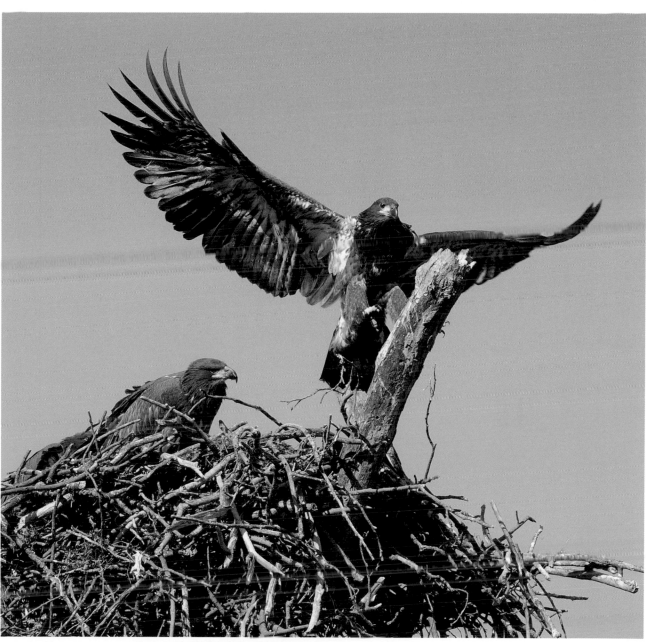

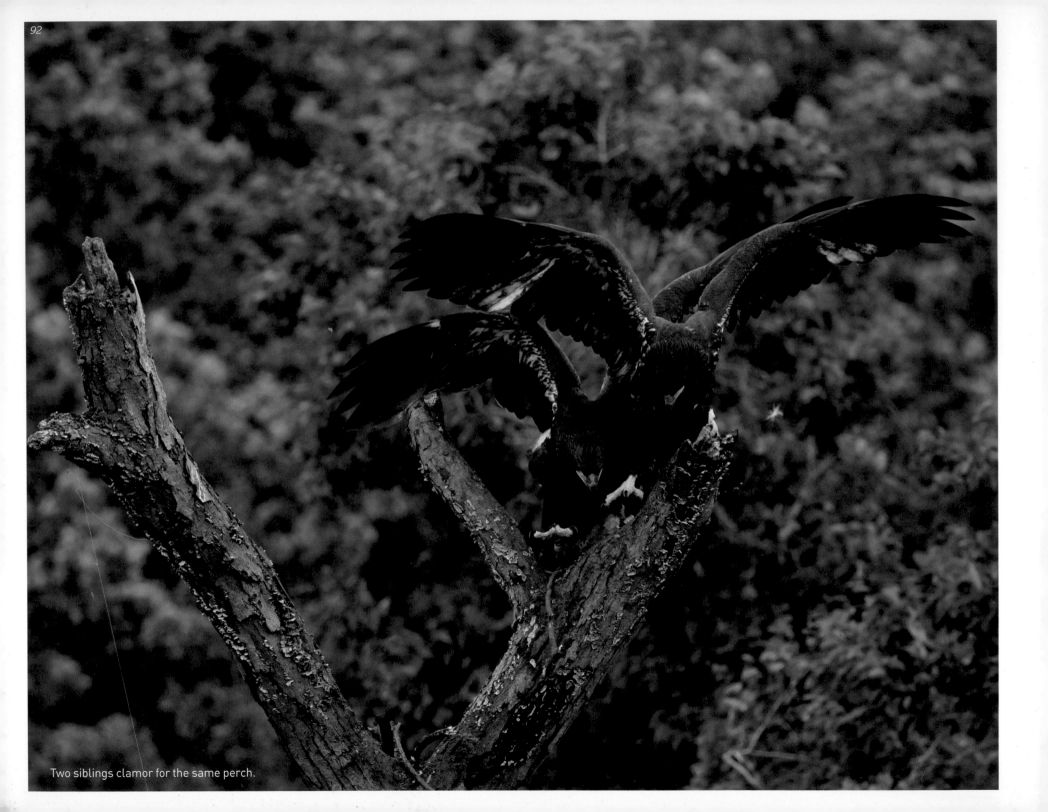

Two siblings clamor for the same perch.

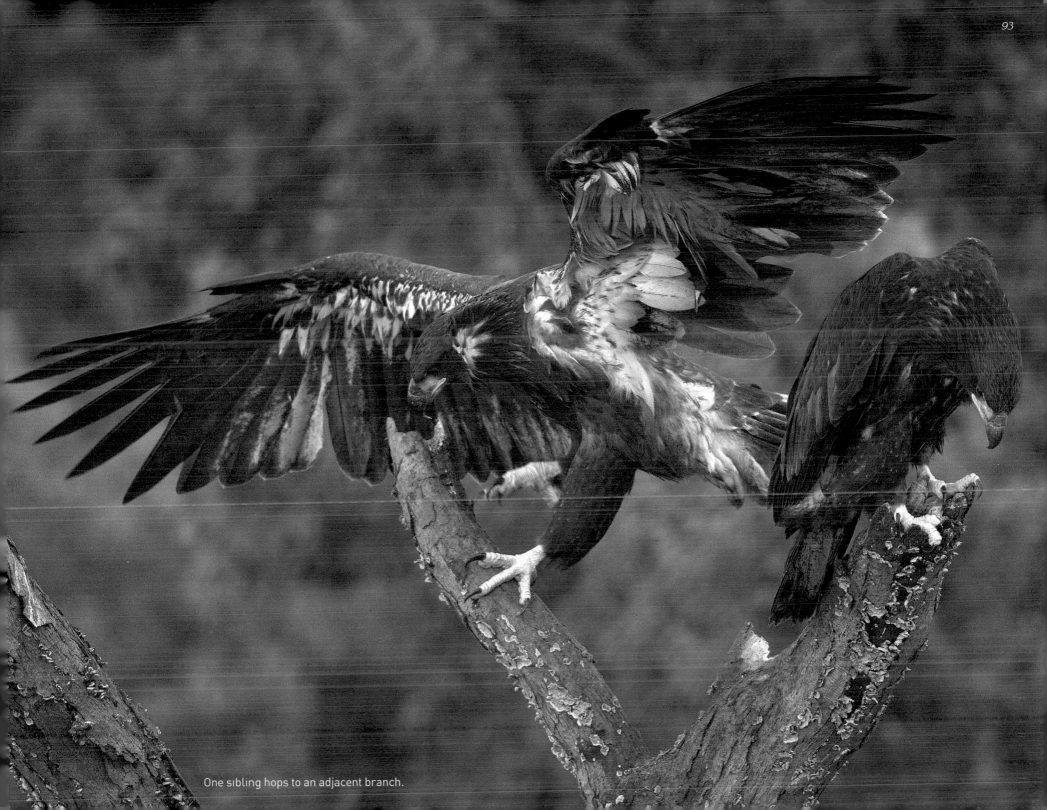

One sibling hops to an adjacent branch.

The siblings spend more and more time away from the nest, perching and now roosting in the nearby trees. They are no longer sleeping at the nest, but occasionally return for food delivered by their parents. Although they are learning to chase and hunt, they have not yet fully mastered skills to forage prey on their own.

For approximately two months, the eagle family unit stays together in their territory along the banks of the Potomac River. The juveniles learn survival skills for life outside the nest from their parents.

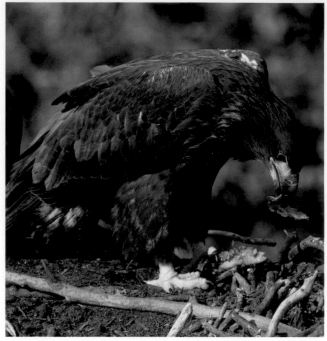

An eaglet returns to devour food left in the nest by its parent.

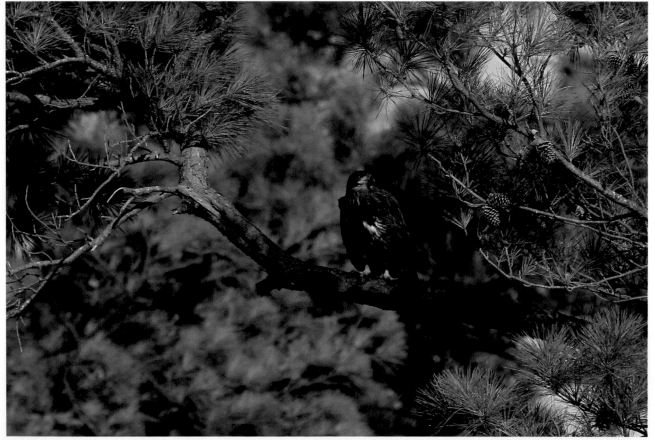

One of the eaglets perches on a branch near the nest tree. © *Teena Ruark Gorrow.*

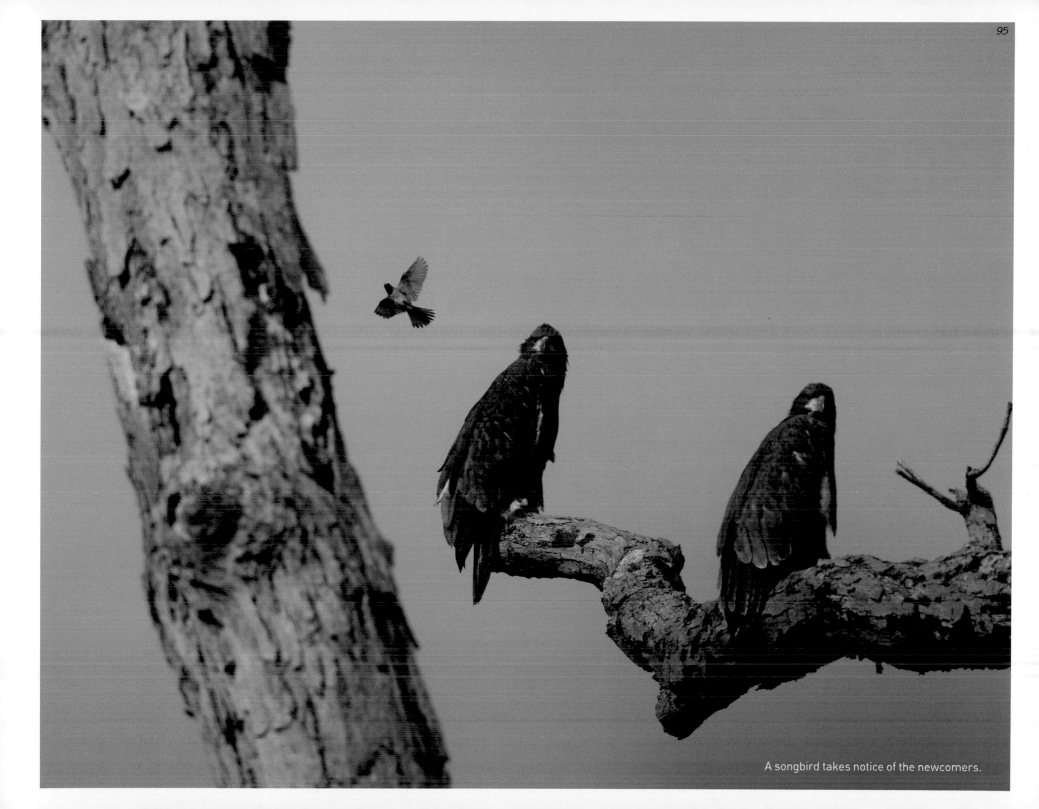

A songbird takes notice of the newcomers.

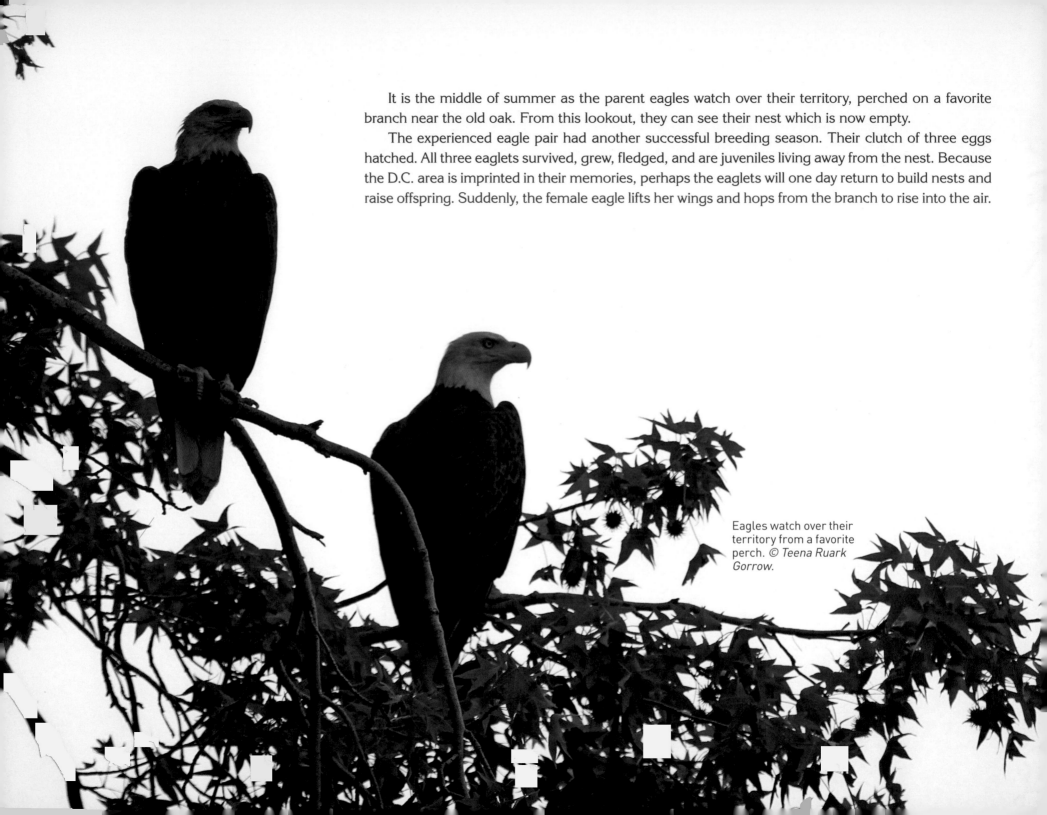

It is the middle of summer as the parent eagles watch over their territory, perched on a favorite branch near the old oak. From this lookout, they can see their nest which is now empty.

The experienced eagle pair had another successful breeding season. Their clutch of three eggs hatched. All three eaglets survived, grew, fledged, and are juveniles living away from the nest. Because the D.C. area is imprinted in their memories, perhaps the eaglets will one day return to build nests and raise offspring. Suddenly, the female eagle lifts her wings and hops from the branch to rise into the air.

Eagles watch over their territory from a favorite perch. © *Teena Ruark Gorrow.*

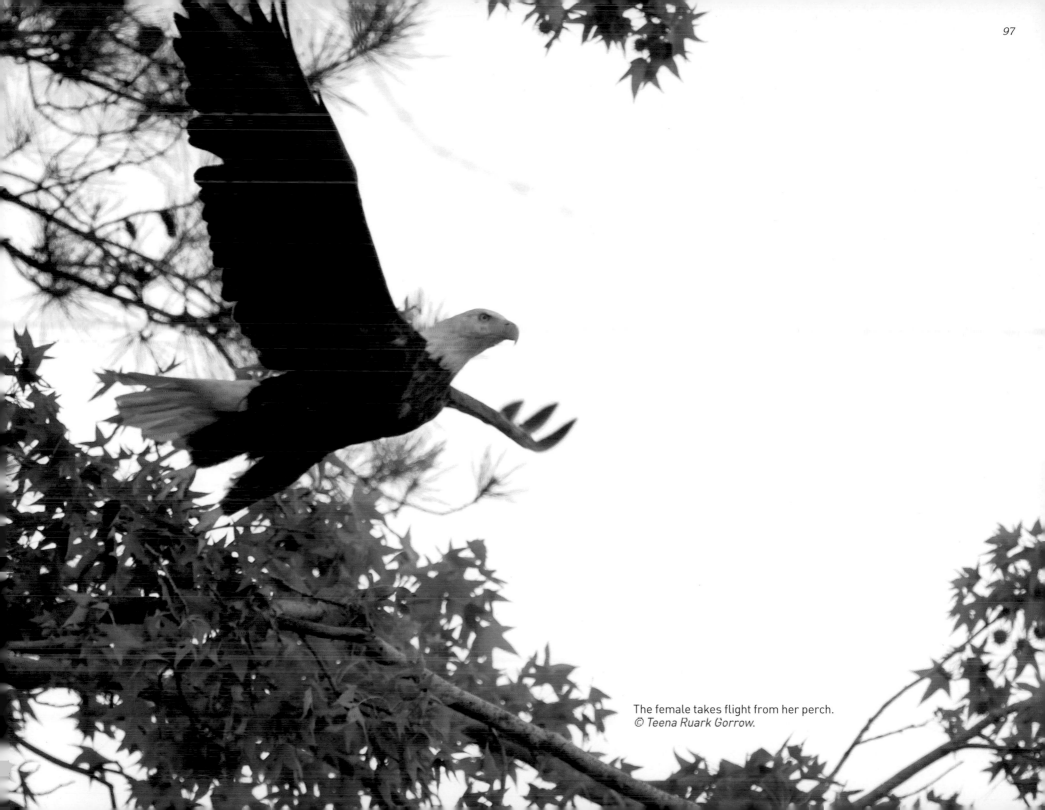

The female takes flight from her perch.
© *Teena Ruark Gorrow.*

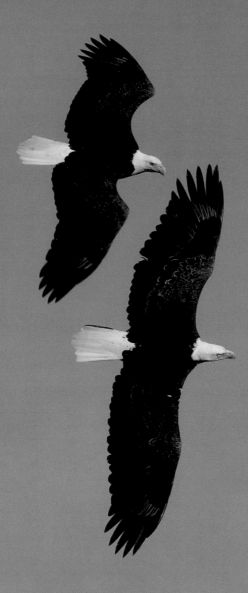

In seconds, the male eagle meets her in the sky. Now that their babies have grown up and moved away, these parents can relax and play. They soar above the clouds with majestic beauty. They outstretch their powerful wings to glide on currents of warm air.

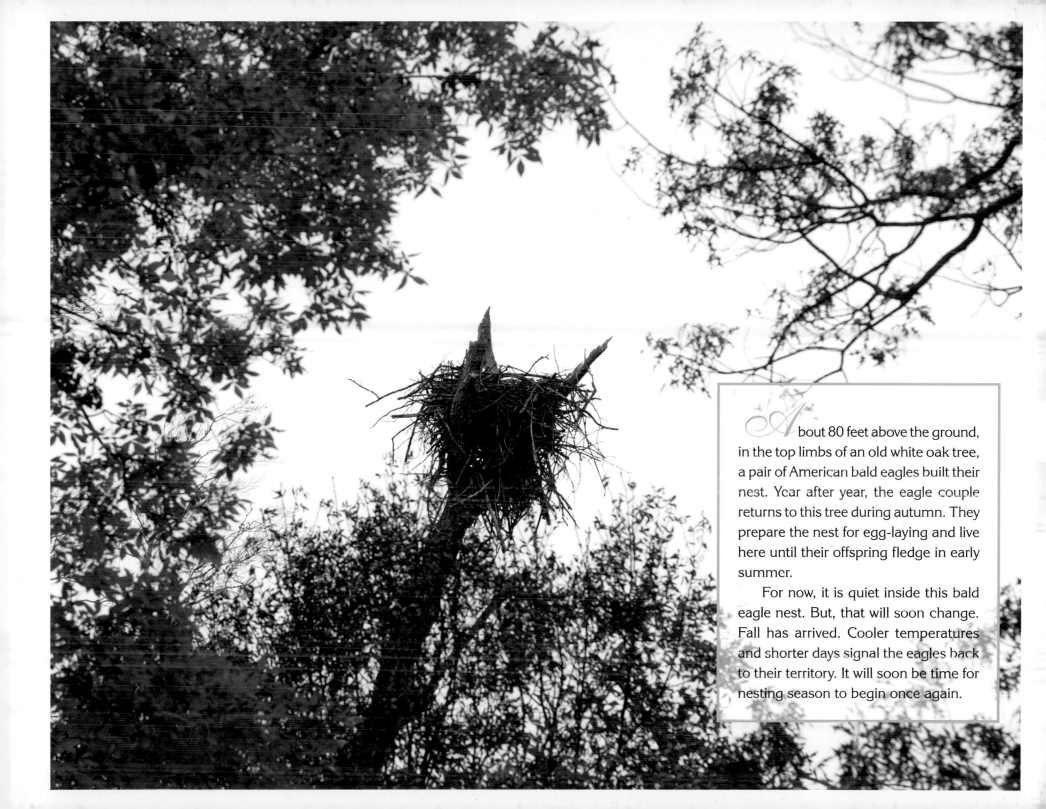

About 80 feet above the ground, in the top limbs of an old white oak tree, a pair of American bald eagles built their nest. Year after year, the eagle couple returns to this tree during autumn. They prepare the nest for egg-laying and live here until their offspring fledge in early summer.

For now, it is quiet inside this bald eagle nest. But, that will soon change. Fall has arrived. Cooler temperatures and shorter days signal the eagles back to their territory. It will soon be time for nesting season to begin once again.

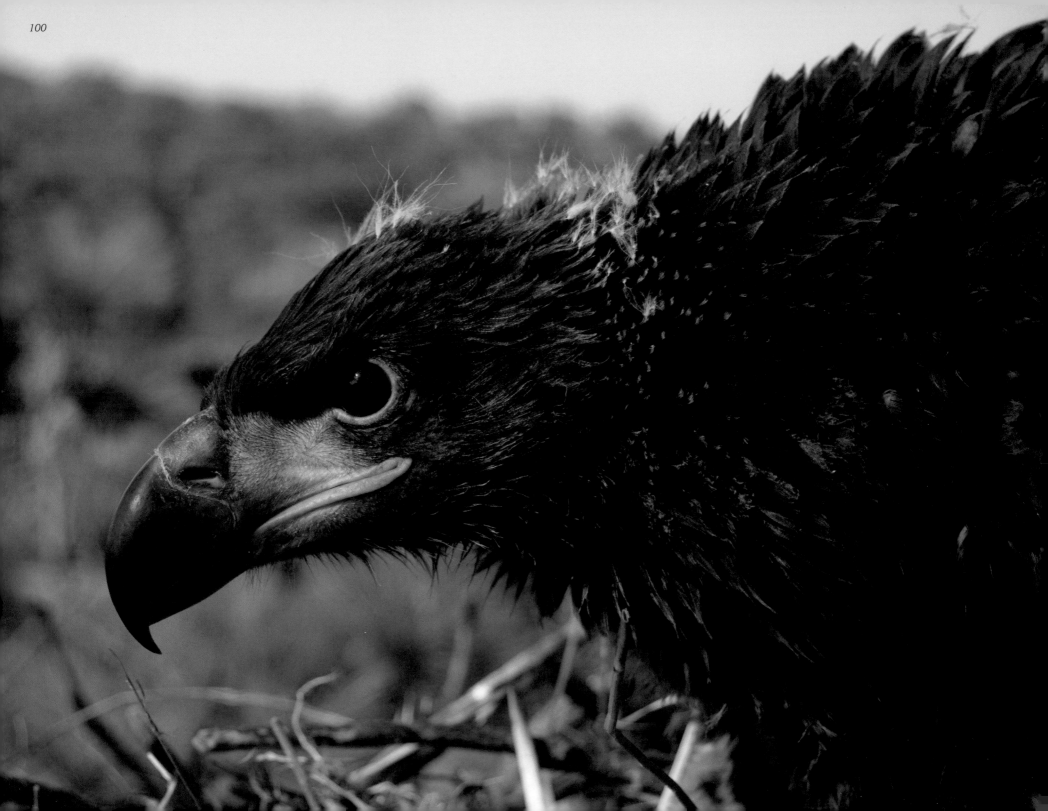

APPENDICES

Appendix A

ETHICS FOR EAGLE ENTHUSIASTS

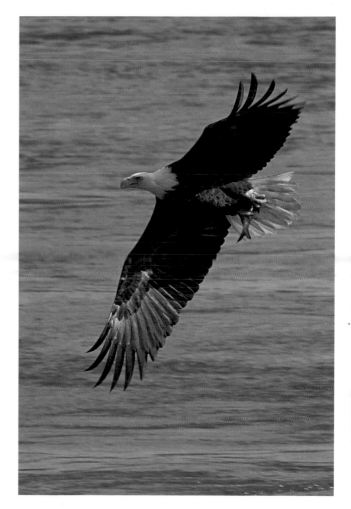

Ensuring the survival of the American bald eagle depends on understanding its way of life, as well as our willingness to conserve and protect it. The opportunity to observe and learn about this magnificent raptor is accompanied by the responsibility to respect its needs and safety. Observers should be mindful that human behaviors can disturb eagle activities.

Please help preserve eagles and their natural habitats by adopting a personal conservation ethic based on these tenets:

• Watch from a distance using a telephoto lens, binoculars, or a spotting scope. If observing for prolonged periods of time, use a blind, vehicle, or natural cover.

• Stay on public roads or trails while observing. Obtain permission before entering private property.

• Be aware that noise and sudden movements can alarm birds and disrupt their normal activity. Watching quietly and moving slowly will create less stress for eagles and increase viewing opportunities.

• Avoid disturbing nesting eagles and their nest trees. Flushing adults from their nests, even for short periods of time, can cause eggs or young to be abandoned. This type of interference is illegal, prohibited under the Bald and Golden Eagle Protection Act.

• Be informed that it is illegal to disrupt any eagle activity or have an eagle feather in your possession without a federal permit. It is illegal to hunt, shoot, or intentionally kill eagles. Collecting eagle eggs or nests is also prohibited.

Photo © Teena Ruark Gorrow.

• Report injured eagles to your state's Department of Natural Resources, game warden, or other law enforcement agency.

• Support wildlife rehabilitation centers to help sick and injured eagles. Volunteering your time, getting involved in a fundraiser, or donating money can help hurting animals have a second chance. Check your area for wildlife organizations and ways you can help.

• Rethink the use of harsh chemicals that could enter waterways, contaminate the food chain, harm eagles and other animals, or otherwise hurt the environment.

• Leave the area clean and undisturbed when enjoying outdoor recreational activities. Recycle or safely discard fishing line, hooks, lures, traps, and trash.

• Learn more about bald eagle protection measures by visiting http://www.fws.gov/midwest/Eagle/guidelines/index.html and http://www.fws.gov/midwest/midwestbird/EaglePermits/index.html

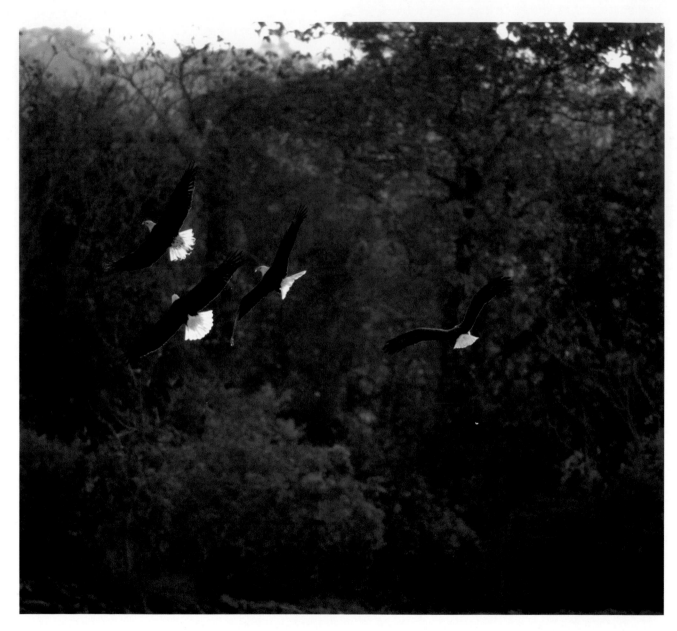

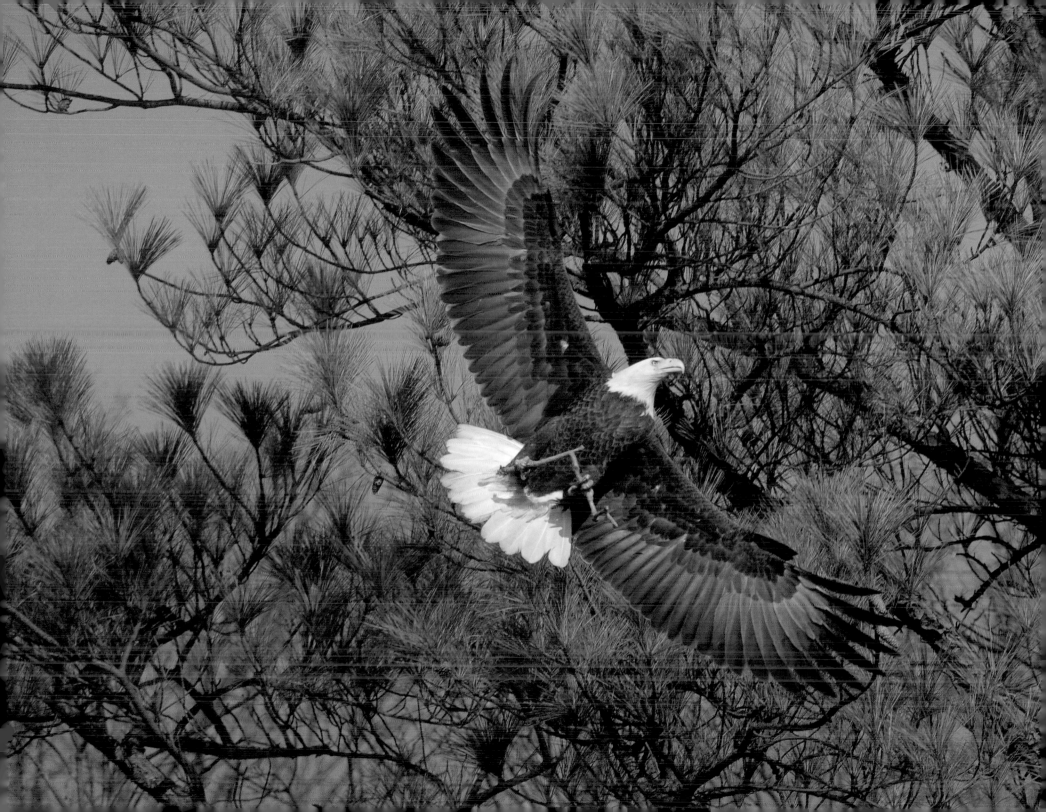

Appendix B:

GLOSSARY

Adult – a mature eagle at least five years old, with completely white head and tail feathers

Branching – a stage of development when eaglets hop from the nest onto tree branches before first flight

Breed – to mate and reproduce

Breeding season – the period during which a mated eagle pair prepares their nest, mates, lays eggs, and raises offspring

Breeding territory – the area defended by a mated eagle pair in which they nest, mate, and reproduce

Brood – the offspring from a single clutch of eggs

Brood/brooding – the act performed by a parent eagle to warm hatched offspring using its body

Brood patch – the area of featherless skin near a parent eagle's abdomen used to incubate eggs or keep hatched eaglets warm

Canopy – the upper layer of a mature group of trees

Carrion – a decayed or dead animal being used as food

Chick – a young eaglet

Clutch – a single set of eggs laid by a female eagle during nesting season

Crop – an area between the neck and stomach where food is stored after consumption

Down – the soft, fuzzy plumage on chicks

Eaglet – a young eagle in the development stages from hatchling through fledgling

Egg cup – the soft cup formed by parent eagles inside their nest to lay eggs

Egg tooth – the hard point of an eaglet's beak used during hatching to crack the shell

First flight – an eaglet's first attempt flying away from the nest

Fledge/fledging – an eaglet experiences first flight and returns to its nest

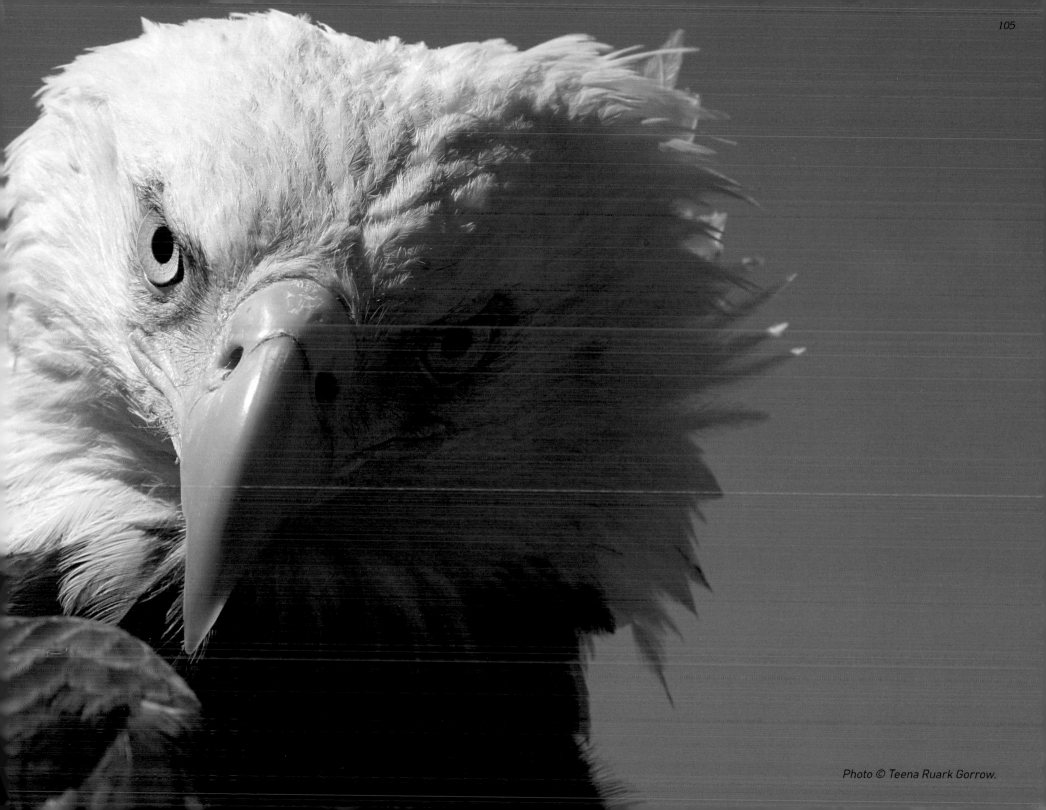

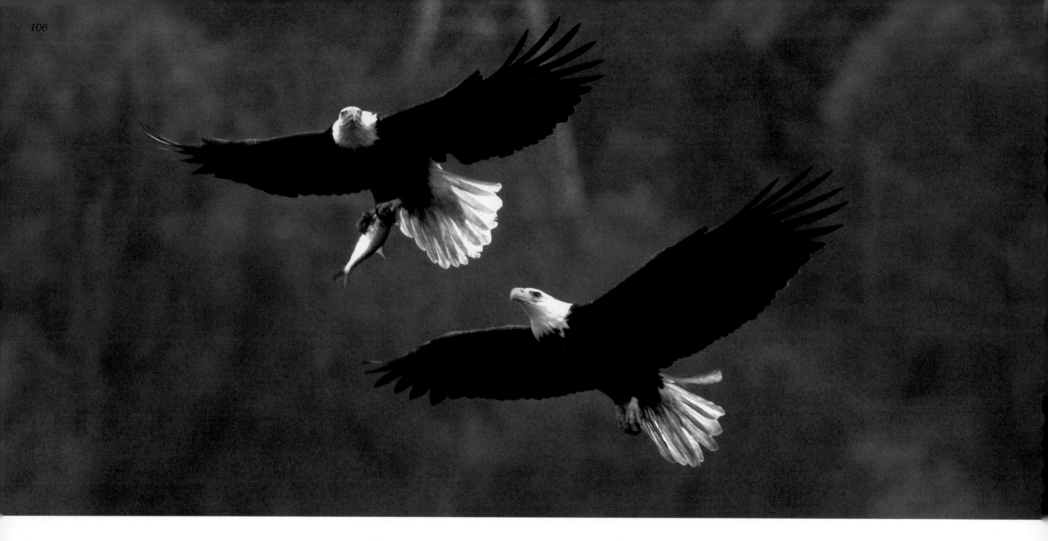

Fledgling – a young bird that has fledged

Flight feathers – the wing and tail feathers which enable an eagle to sustain flight

Forage – to search for live food or carrion

Glide – to fly in a smooth, even manner with outstretched wings and little apparent movement

Habitat – an eagle's living environment

Hatching – a process during which an eaglet fractures its shell and becomes free from the egg

Hatchling – a recently hatched eaglet; newborn

Incubate – to apply body heat while sitting on a clutch of eggs

Juvenile – a young eagle, under one year old, that is experienced with flight and living away from the nest

Nares – nostrils which are located on the upper portion of an eagle's beak

Nest – a structure consisting of sticks and soft lining prepared by a mated eagle pair for laying eggs and raising offspring

Nesting season – the period during which a mated eagle pair prepares their nest, mates, lays eggs, and raises offspring

Nestling – an eaglet confined to its nest, not yet able to fly

Offspring – the young eaglet(s) produced by a mated eagle pair

Peeping – the short, penetrating vocalizations of an eagle chick

Perch – to rest, sit, hunt, or stand watch from a high limb during daylight

Pipping – cracking an eggshell from the inside to break free

Plumage – an eagle's body and flight feathers

Predator – an animal that forages other animals for food to survive

Preen – to groom or position feathers

Prey – an animal foraged for food

Raptor – a large bird that hunts and captures live prey or carrion for food

Roost – to sleep, rest, or find shelter at night or during inclement weather

Snag – a dead tree

Soar – to mount the air with an ascending, circular flight using little wing motion

Talon – hooked, sharp claw of an eagle

Tarsus – the ankle area of an eagle's leg and foot

Territory – the area defended by a mated eagle pair in which they nest, mate, and reproduce

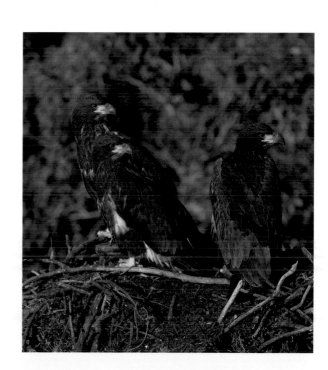

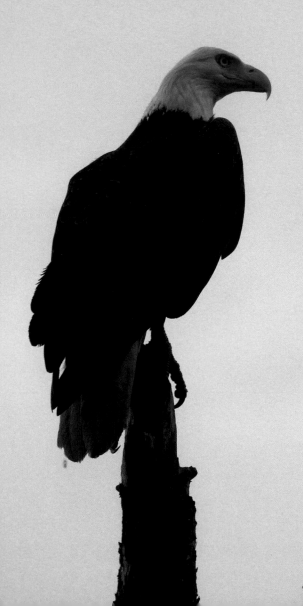

Appendix C

RESOURCES

Bald eagle enthusiasts can find an array of resources on the Internet including links to eagle nest cams; national wildlife refuges; general bald eagle information; wildlife, eagle, and/or avian centers and organizations; and magazines. Some of our favorites are listed as follows:

Bald Eagle Nest Cams
American Eagle Foundation Nest Cam:
http://www.ustream.tv/americaneaglefoundation

Blackwater National Wildlife Refuge Live Eagle Cam:
http://www.friendsofblackwater.org/camhtm2.html

Decorah Eagles Cam
http://www.ustream.tv/decoraheagles

EagleCam Live from the National Conservation Training Center
http://outdoorchannel.com/Conservation/EagleCam.aspx

National Geographic Eagle Webcam
http://animals.nationalgeographic.com/animals/birds/eagle-cam-live

National Wildlife Refuges
U.S. Fish & Wildlife Service National Wildlife Refuge System
http://www.fws.gov/refuges/

Photo © Teena Ruark Gorrow.

General Bald Eagle Information

U.S. Fish & Wildlife Service
 http://www.fws.gov/

Bald Eagle
 http://digitalmedia.fws.gov/utils/getfile/collection/natdiglib/id/8791/filename/8792.pdf

Bald Eagle
 http://www.fws.gov/midwest/eagle/

Bald Eagle Nesting Seasons
 http://www.fws.gov/midwest/eagle/pdf/nest-seasons.pdf

Fact Sheet: Natural History, Ecology, and History of Recovery
 http://www.fws.gov/midwest/eagle/recovery/biologue.html

Digest of Federal Resource Laws of Interest to the U.S.
Fish and Wildlife Service
 http://www.fws.gov/laws/lawsdigest/migtrea.html

The Bald and Golden Eagle Protection Act
 http://www.fws.gov/midwest/midwestbird/
 EaglePermits/bagepa.html

Bald Eagle Protection Act of 1940
 http://www.fws.gov/laws/lawsdigest/BALDEGL.HTML

Migratory Bird Treaty Act of 1918
 http://www.fws.gov/laws/lawsdigest/migtrea.html

Eagle Permits
 http://www.fws.gov/midwest/midwestbird/EaglePermits/index.html

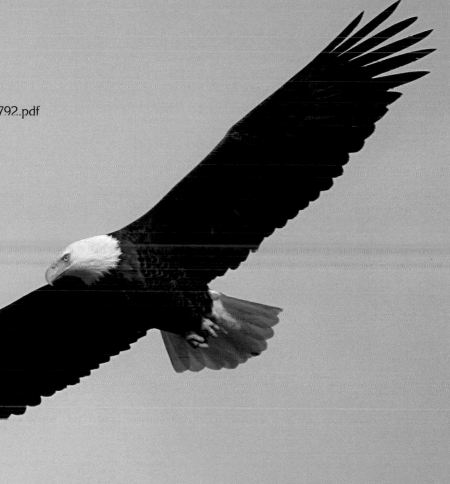

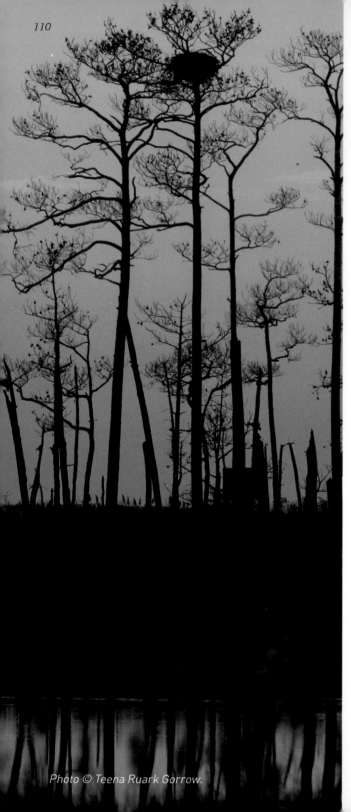

Bald Eagle Management Guidelines and Conservation Measures
http://www.fws.gov/midwest/Eagle/guidelines/index.html

Links to More Information
http://www.fws.gov/midwest/eagle/links.html

Wildlife, Eagle, and/or Avian Centers and Organizations
American Bald Eagle Foundation
http://baldeagles.org/

American Eagle Foundation
http://www.eagles.org/

Eagle Institute Delaware Highlands Conservancy
http://www.eagleinstitute.org/

National Eagle Center
http://www.nationaleaglecenter.org/

National Wildlife Federation
http://www.nwf.org/

Sutton Avian Research Center
www.suttoncenter.org

The Center for Conservation Biology Eagle Nest Blog
http://eaglenest.blogs.wm.edu/

The Wildlife Center of Virginia
http://wildlifecenter.org/

Magazines

Outdoor Delaware Magazine

http://www.dnrec.delaware.gov/Admin/Pages/OutdoorDelaware.aspx

Maryland Natural Resource Magazine

http://www.dnr.state.md.us/naturalresource/

Virginia Wildlife Magazine

http://www.dgif.virginia.gov/virginia-wildlife/

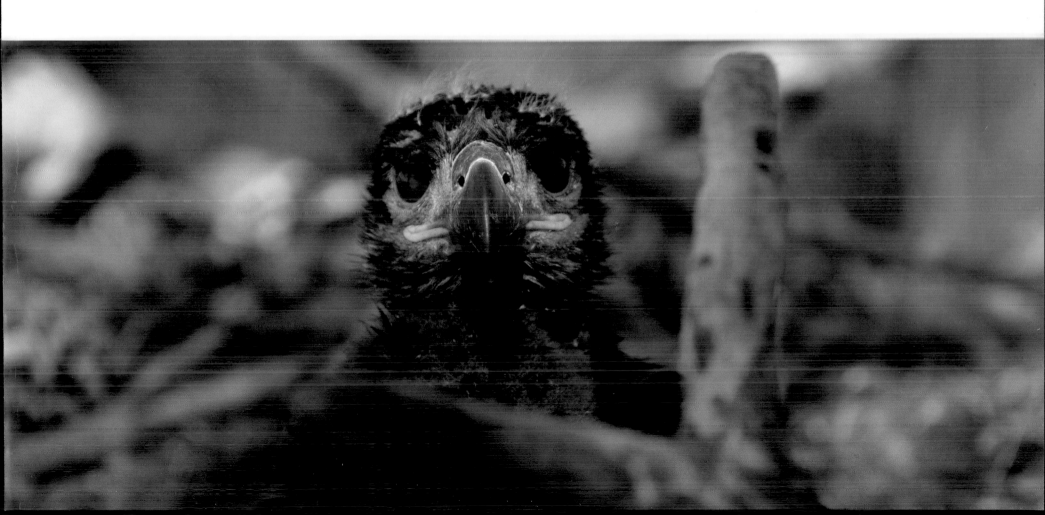

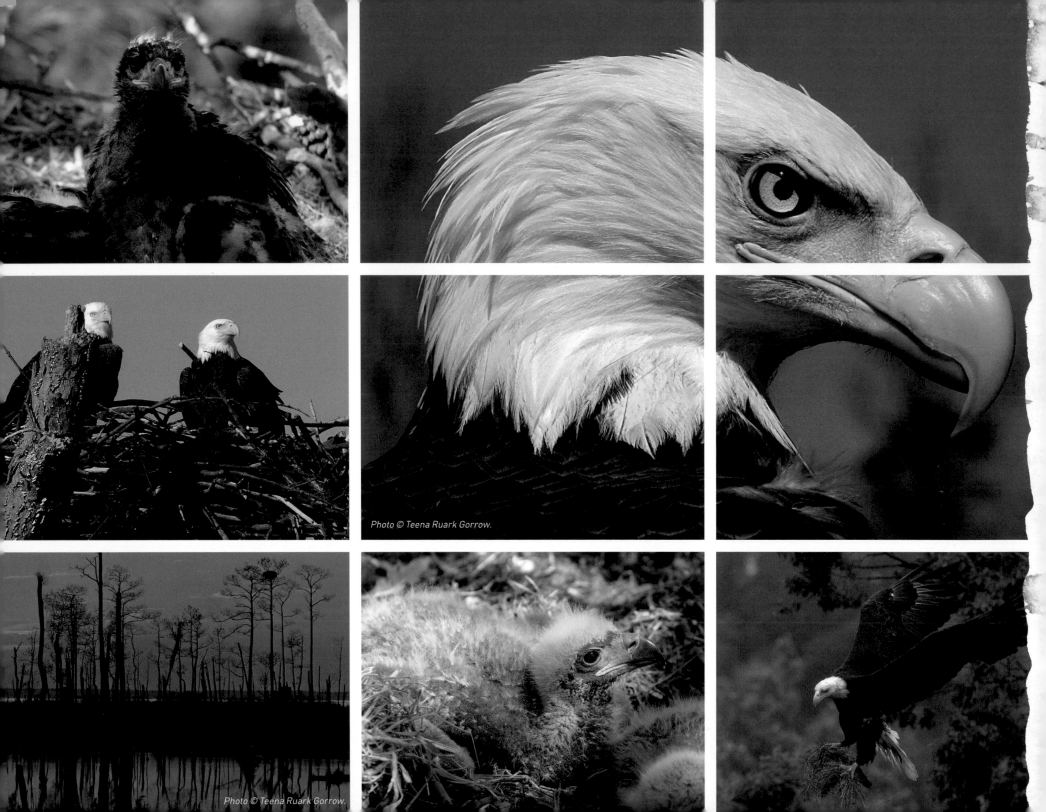

Photo © Teena Ruark Gorrow.

Photo © Teena Ruark Gorrow.

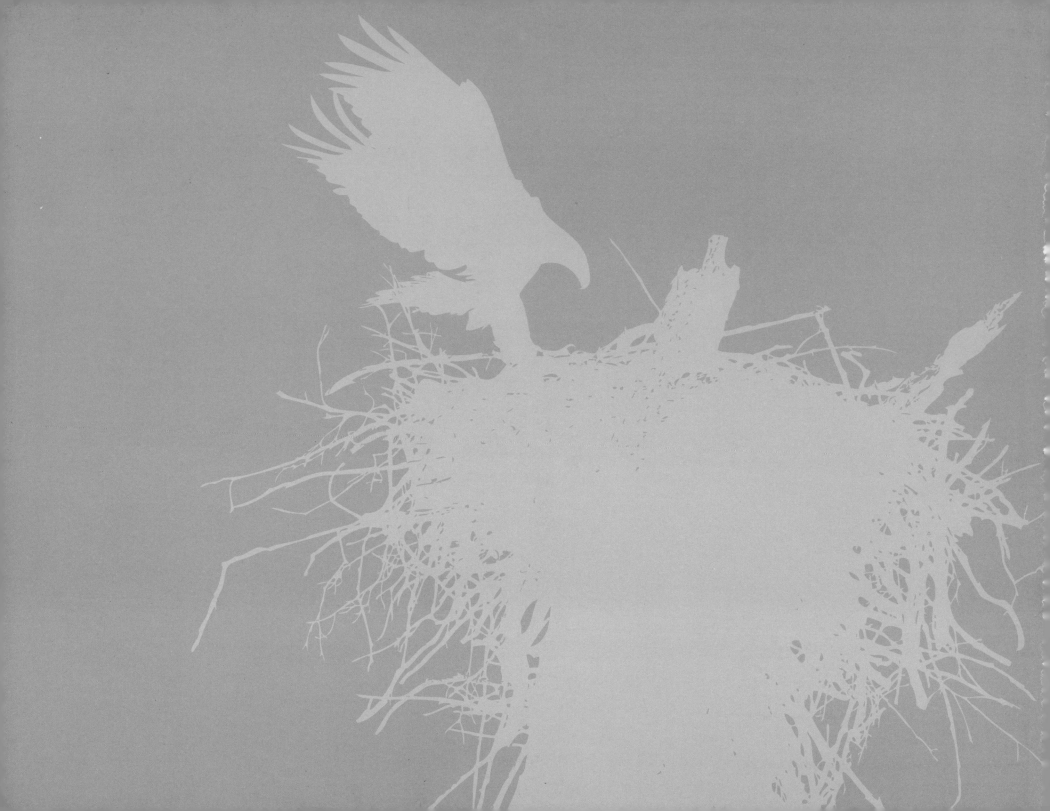